BORDER COUNTIES RAILWAY

THROUGH TIME

Roy G. Perkins

With Iain MacIntosh

AMBERLEY

Preface

The reader is asked to note that where possible equivalent contemporary views to the historic photographs have been provided, though this has not always been feasible because of tree growth, ground level and in particular between Kielder and Plashetts due to the construction of Kielder water and the Bakethin Resevoir. The course where exposed at these locations are featured within this book. Such cases are noted within the script. We apologise for such examples but a visit to the sites involved will illustrate the difficulties.

The walks around Kielder Water are heartily recommended by this author.

Iain MacIntosh.

First published 2014

Amberley Publishing
The Hill, Stroud
Gloucestershire, GL5 4EP

www.amberley-books.com

Copyright © Roy G. Perkins with Iain MacIntosh , 2014

The right of Roy G. Perkins with Iain MacIntosh
to be identified as the Authors of this work
has been asserted in accordance with the
Copyrights, Designs and Patents Act 1988.

ISBN 978 1 4456 1390 1
E-book ISBN 978 1 4456 1397 0

British Library Cataloguing in Publication Data.
A catalogue record for this book is available from the British Library.

Typeset in 9.5pt on 12pt Celeste.
Typesetting by Amberley Publishing.
Printed in the UK.

The Border Counties Railway

The Border Counties Railway (North Tyne Section) was authorised by an Act of Parliament of 1854 to build a line of railway of 26.25 miles from Border Counties Junction, west of Hexham on the Newcastle and Carlisle Railway, to Belling Burn near Falstone. The Company itself appears to have been formed some time earlier, in 1851 in fact. In 1853 one Robert Nicholson was appointed as engineer for the nascent railway and the Prospectus was laid before parliament on 29 November. Haste never seems to have featured heavily in the scheme of things with the Border Counties, and it was to take until December of 1855 before the company bestirred itself into arranging the, by then, traditional ceremony of 'cutting the first sod' an act which was eventually performed by W. H. Charlton the first Chairman of the BCR and a prominent local landowner. In fairness to the Border Counties Railway and its Chairman it should be pointed out however that they had to contend with unexpected difficulties when on 9 May 1855 at the fairly young age of 46 Robert Nicholson, died following a short illness. At the time he had just completed his work as engineer of the Severn Valley Railway and work was about to start on the Border Counties Railway. Fortunately as early as 1838 Nicholson had taken on, as an apprentice, his nephew one John Furness Tone who apart from assisting Nicholson on a number of parliamentary and construction works, acted as Resident Engineer on the Newcastle and North Shields Railway, and the earliest works of the Blythe and Tyne Railway. It was perhaps not entirely irrelevant that in 1860 Tone was to lease the coal workings at Plashetts from the Duke of Northumberland.

Between 1857 and 1858 Tone was engaged on behalf of the North British Railway in their battle with the Caledonian Railway to build a line of railway southward from Hawick towards Carlisle, entitled the Border Union Railway, which, together with its associated branch line to Langholm, subsequently became known as the Waverley Route. It is at this time that Tone became familiar with Richard Hodgson the then Chairman of the North British Railway. So it was that John Tone came to be retained as engineer for the Border Counties Railway. Also in 1855 William Hutchinson was contracted to build the first section of the line, though in fact he was to go on to build the entire line. Already thinking big in 1856 the Border Counties directors ordered a survey to be undertaken for a route into Scotland, before even a yard of the Border Counties had been built let alone opened.

The milestone of opening the first section of the railway, that from Hexham to Chollerford a distance of some 5 miles, was achieved on 5 April 1858. Chollerford Station itself was renamed Humshaugh on August 1919 to avoid confusion with the similarly named Chollerton, nearby. However it would appear that even before the opening of the railway to Chollerford an engine shed had existed at Howford, just to the north of Border Counties Bridge over the River Tyne. Details are at best sketchy but this would appear to have been a two road shed built in stone and demolished when the new engine shed was constructed at Reedsmouth in 1862. What is not clear is whether the Howford shed was built by the BCR or was a pre-existing shed possibly associated with the quarry at Howford or with the coal workings at nearby Acomb.

The first major engineering obstacle to be overcome on leaving Hexham was a bridge over the fast flowing River Tyne at Border Counties Junction. This structure soon proved problematical when even at the construction phase the temporary timber structure which had been put in place to aid construction work contrived to give way and deposit the crane, which had been brought in to facilitate the building of the main bridge, into the river. Sadly this was to prove an omen, for this bridge, as we shall see, was to provide a major problem for the rest of the life of the Border Counties Railway.

The first station to be encountered out of Hexham was that at Wall which was opened on 5 April 1858, the same day as Chollerford. The station was located on a track off the A6079 about 0.5 miles south of the village of Wall, and can be seen from the grounds of the Hadrian Hotel. It was a small station of no particular significance except when particularly heavy trains necessitating two locomotives or more had to be used. On such occasions the restrictions imposed by the Civil Engineer decreed that double heading was forbidden and the train engine would have to haul the train forward to Wall unaided where it could be recoupled to its partner(s) and the train could run forward toward Reedsmouth and beyond. In terms of buildings it has to be said that Wall was a fairly uninspiring station. A single storey station building stood on top of the largely timber faced platform on the up side of the line and was linked to another single storey building toward the south end of the platform. There was a later concrete faced platform extension which was probably added. Track wise it consisted of the running line and two loops standing opposite the platform with head-shunts. It was never heavily used and closed 19 September 1955, earlier than the rest of the line, but not before its Station Building had been heavily damaged by fire during the 1940's and similarly its signal box in 1955.

Also opened on 5 April 1858 was Chollerford Station located on the eastern side of the 'Military Road' B6318 near the end of Chollerford Bridge over the River North Tyne. The former station has been converted in to an attractive private residence with the running line and goods yard area lawned over. The stone-faced platform was located on the down side of the running line and surmounted by a two storey station building built to an L plan and enhanced by raised gables. Track–wise there were two loops running parallel with the platform face two spurs running behind the platform and serving the goods shed and cattle-dock respectively. The goods yard also contained a two-ton crane and a weigh-bridge. Running off the more northerly of these spurs and parallel to the running line was a third loop which ended at the platform ramp. The small signal box was also located at the northern end of the station a little further north than the platform end.

On and from 1 August 1919 the station was re-named Humshaugh after a village about 0.75 miles away in order to avoid confusion with the next station on the line at Chollerton. Good, if distant, views of the station complex are afforded from the terrace of the George Hotel on the opposite side of the River North Tyne.

After the celebrations which accompanied the opening of the railway to Chollerford in April 1858 the BCR Board received a reality check when word reached them that their ambitious plans for an extension into Scotland had been refused by Parliament. Nothing daunted the BCR resolved to try again and another application was duly lodged in 1859.

In the meantime another railway scheme which was to have an immediate bearing on the Border Counties' plans had come into being. The Wansbeck Valley Railway as it was correctly known received Royal Assent on 8 August 1859 for a 28 mile line from Morpeth to a junction with the Border Counties Railway at Reedsmouth and a branch line to join the Blythe and Tyne Railway as well as another to join the North Eastern Railway. However enough of this digression, to return to the Border Counties, still proceeding northward. The next station was Chollerton.

At Chollerton the original building still survives, albeit converted into a private dwelling, on the west side of the A6079 immediately to the south of the village of Chollerton. A portion of the original platform also survives at the south end of the site still surmounted by the small goods shed. The goods sidings, goods yard would be too grand a title, contained two loading docks and crane with a capacity of 3 tons. Chollerton never boasted a signal box, the sidings being operated by a ground frame. Chollerton first appeared in the timetable on 1 June 1860 and was closed to passengers on 15 October 1956 and for all traffic on 1 September 1958.

The next station on our northward progress came at Barrasford, a diminutive station slightly over a mile from Chollerton. Here was a substantial station building with a single siding and head shunt controlled by a ground-frame which, unusually, was situated within slate roofed wooden shed, located just off the northern end of the passenger platform which was on the down side of the running line. There was a further siding slightly to the north which was also controlled by the ground-frame at Barrasford station. A mile further north from Barrasford Station was Barrasford Quarry operated from 1876 by the Northumberland Whinstone Company and comprising a 2ft gauge railway to serve the BCR's sidings. The 2ft gauge network also served Sir James Steel's Gunnerton Quarry and was operated by a number of small locomotives.

Continuing northwards the next station we come to is Wark some four miles distant. The main station buildings at Wark were not dissimilar to those at Barrasford though the raised gables at Wark distinguish it from the latter. The passenger platform at Wark was situated on the up side of the running line with a goods loop directly opposite it. There was also a loading bank alongside a goods shed on the down side at the southern end of the passenger platform. The station buildings are still in existence though the waiting room has been extended by the addition of a second storey albeit in a very sympathetic style. Perhaps surprisingly for a station of such importance Wark was not initially graced with a signal box. However an accident in 1889 resulted in the up-grading of the signalling on the entire line and Wark in its turn received a signal box although situated some 200 yards to the north of the station itself.

One of the biggest problems facing the Border Counties Railway during its independent existence was a perennial shortage of money, and this may have been the reason for the choice of its next terminus at Countess Park. Even by Border Counties standards this station was singularly devoid of likely railway traffic. It was opened on 1 December 1859 and survived for little over a year, closing on 1 February 1861. During its brief existence Countess Park was furnished with a temporary platform and a run-round loop. The loop was retained for some years after the station closed for the carriage of stone from the Mill Knock Quarry, about a mile to the north, which had begun to emerge as a source of traffic.

Reedsmouth was the next port of call on our northward progress. This station first appeared in timetables on 1 May 1861 but was in operation only briefly. The reason for the rapid demise of Reedsmouth in its first incarnation has already been briefly touched on: The Wansbeck Valley Railway. As we have already seen above this railway was authorised by Parliament on 8 August 1859 barely a year after the Border Counties had opened its first section of line, from Hexham to Chollerford (later re-named Humshagh), and was driving Northward. The WVR Act provided for a junction at Reedsmouth, where by May 1861 the Border Counties already had a station albeit a fairly diminutive affair. Unfortunately history does not relate just how close or otherwise relations were between the Border Counties and the Wansbeck but they can't have been very close because the BCR (Border Counties Railway) now had to abandon its newly built station in order to accommodate the WVR (Wansbeck Valley Railway). There were further complications too. Richard Hodgson, Chairman of the North British Railway was on the board of the Wansbeck and his plan was to use the WVR to run through trains to Newcastle via the Blyth & Tyne Railway and thence into the Blyth & Tyne's newly opened station at New Bridge Street. Following extensive negotiations with the North Eastern Railway an agreement was reached whereby the BCR trains would be allowed to run in to the North Eastern Railway's Newcastle Central Station. In return the North Eastern Railway would haul all the 'Scotch Expresses' right through to Edinburgh. The outcome of these events was that quite clearly that the bulk of the traffic conveyed by the BCR from the north would find its way southward to Hexham rather than eastward to Morpeth. The WVR would from then on find itself condemned to its fate as an obscure by-way.

All of these shenanigans resulted in a re-alignment of Reedsmouth from west facing junction to south facing junction in consequence of which the existing station at Reedsmouth was abandoned. Located near to where the still extant Engine Shed stands at the southern end the five arch viaduct over the River Rede this original station had two platforms, which were not opposite each other, a passing loop, and little else.

The new station was an altogether grander affair. The Border Counties line through the station was double track with two platforms opposite each other whilst the Wansbeck was a single line positioned at about 45 degrees to the Counties. Alongside the running line of the Counties stood a large engine shed with accommodation for six locomotives and alongside that a covered coaling stage. There were also a couple of carriage sidings. On the Wansbeck platform face were a series of loops for the reception and marshalling of goods wagons. In addition and taking its access from the Wansbeck line there turntable, albeit a small one giving access to accommodation for a railmotor for the use of the permanent-way staff. Particularly on its southern approaches the station was blessed with a particularly fine array of North British lower quadrant signals.

Atop the apex of the junction stood a signal box, which while originally of diminutive single storey construction was rebuilt to aid all-round visibility in 1918 when a second storey was added to create the structure which we are familiar with today. Adjacent to the signal box stood the rectangular mass of the station building surmounted originally by a huge water tank. The water tank was removed after the station had closed to facilitate conversion into a dwelling house about the same time as the signal box was similarly converted. There was also a subway under the lines to link the up and down platforms of the Border Counties which was later supplemented by a footbridge.

Reedsmouth first appeared in railway timetables from 1 May 1861, however this was the original station as already described. The original station closed on 1 November 1864 the same day as the then new station was opened. On 15 October 1956 Reedsmouth finally closed its doors to passengers and on 11 November 1963 it was closed completely. It had existed for just 99 years.

Bellingham was and remains the 'capital' of the North Tyne Valley and as such was an important traffic centre. Typically this was reflected in its railway station. The station buildings dominate the street scene on leaving Bellingham by way of the road to Reedsmouth. Bellingham station stands a little over two miles to the north of Reedsmouth yet a typical timetable shows that trains were allowed a more than generous 5 minutes for the arduous journey over what can be best described as an undulating road. The frontage of the station building onto the road stands some three storeys while that to the railway platform is but two. This elevated position above the street scene lends the railway station an air of authority which is, sadly, now misplaced. No more beer trains from the breweries of Edinburgh, no more meat trains destined for London markets, still less a local train from Reedsmouth to collect the school children whose homes lay in Scots Gap or Cambo. The station building at Bellingham still stands, and is now in use as offices while the station yard has been neatly re-cycled by the Council as a depot and the whole site has a cared for appearance, largely through the efforts of the Bellingham Heritage Centre and the local Tourist Office. Standing at the platform face as a result of the Heritage Centre's efforts are two former British Railways coaches to be used to house exhibitions of the history of the Border Counties and Wansbeck Valley Railways. While the railway was still operational the station consisted of three sidings all constructed as loops from the running line, and an end-loading dock for livestock traffic. The passenger platform as built was just a hundred yards long, but was later extended to 160 yards. This platform also accommodated a signal box and a small goods shed whist just to the east of the passenger platform was the token exchange platform. Bellingham Station was opened on 1 February 1861 and closed to passengers 15 October 1956 and to all traffic on 11 November 1963. During the 'inter-regnum' between the closure to passengers and the closure to all traffic there were occasional specials, the last being a ramblers excursion on 7 September 1958.

Charlton Station was another short lived BCR venture opening on 1 February 1861 and closing on 1 October 1862. The station was built to serve the tiny farming hamlet of the same name and was provided with a solitary siding albeit some 200 yards away to the east. Facilities at Charlton were restricted with just a timber built platform and a shelter. It was situate about two miles north of Bellingham.

Continuing northward the next Halt came at Tarset, once more it was a fairly inconsequential stopping place some one and a half miles north of Charlton, built to serve Tarset Hall, and the hamlets of Lanehead and Greenhaugh. There is some evidence that for a period between 1914 and 1925 Tarset boasted its own signal box though precise dates for its inception and discontinuance have proved elusive and in the absence of these the case must be viewed as unproven. Throughout its existence Tarset boasted a single siding located to the south of the passenger platform and equipped with a loading bank and two ton crane. The passenger traffic was not substantial but seems to have consisted of a steady trickle of travellers and certainly even when faced with imminent closure it was neat and well maintained. Tarset Station was opened on 1 February 1862, and closed to passengers on 15 October 1956 and to all traffic on

1 September 1958. These closure dates however only tell half the story because on and from 19 September 1955 Tarset station was downgraded to the status of an unstaffed halt. With its neat dressed stone construction Tarset has long been in residential use with trees starting to obscure the view of it from the nearby road overbridge.

Meandering gradually northward the next station we reach after Tarset, is Thorneyburn if anything marginally less important than Tarset and little more than a mile further north. Indeed Thorneyburn had only one period of fame that was when in 1861 it was from 1 February until 2 September the northern terminus of the Border Counties. It was indeed a diminutive station with a platform barely 50 yards long which was never extended or raised to meet later standards, no station house, but a gatekeeper's cottage. The platform was diagonally opposite the gatekeeper's cottage on the other side of the level crossing though little of the former remains. In fact the platform was so low that passengers were provided with steps to join or leave the train. The station was opened on 1 February 1861 and closed on 15 October 1956 to passengers. For some substantial periods Thorneyburn did not receive a daily service, for example for extended periods trains stopped only on a Thursday. During the seven month period when Thorneyburn was the acting terminus of the line it was equipped with a siding and a loop, but these did not last long. The gatekeeper's cottage has for some years been in residential use and is well tended. The gates of the level crossing have been replaced with modern facsimiles.

All the stations north of Reedsmouth have the same basic plan, they are long and narrow, as if they were built on shelves running round some enormous room. The reason for this is not hard to discover, basically the railway tries to follow the river and clings to the valley side as far as it can. Falstone station our next port of call is a particularly good example of this perched as it is somewhat higher than the village it serves. The station here was opened on 2 September 1861 and passenger services were withdrawn, as they were on the entire line, on 15 October 1956. The line battled on for nearly two years until bowing to the inevitable when freight services too were discontinued on 1 September 1958. The station itself contained a platform of some 85 yards on which stood the substantial station house, as well as the signal box. Opposite the platform ran a loop, while to the south end was a further siding containing a goods dock. There was one further siding on the up side of the line to the north of the station. Today the Station house remains in good order though much altered, not least by an extension linking the station house to the signal box, which has also been extended to the rear.

Outside the station limits was one further siding which provided access to a tramway which served the diminutive Hawkhope Hill Colliery, on the hillside above the village. This small colliery, which at its peak employed some 25 people closed in 1914, following flooding, only to re-open for a time in the 1930s.

On leaving Falstone the railway climbed at gradients varying from 1 in 100 to 1 in 1,000 past the siding which served Hawkhope Hill colliery until after a couple of miles it started its descent into the 'Plashetts declivity' at a ruling gradient of 1 in 133. It must have come as something of a shock to passengers used to watching the rural panorama which lay to the south of Falstone to be suddenly be plunged into the industrial landscape which constituted Plashetts. From the outset this had been the objective of the railway's construction for the Border Counties and now the North British had plans to export the coal which could be won here. At its peak around 1914 there were three pits at

Plashetts, Bank Top, Seldom Seen and Far colliery between them providing employment to some 126 men and boys, with over two thirds of them below ground, producing some 30,000 tons of coal per annum. In addition there was a brick works and a tile works plus the usually associated processes such as screens as well as a network of railway lines both standard and narrow gauge to bring the coal from the coal faces to the railway station. Even allowing for the lines serving the coal faces Plashetts was a significant sized station. After completing its ambling progress downhill from Falstone the railway entered a broad basin of land locked in the midst of the surrounding hills where it swept in a graceful curve which changed its direction from south-south-west to north-west. Unfortunately the coal from Plashetts proved unsuitable for the industrial applications which its promoters had in mind for it because it did not prove to be good steam coal. It was however perfectly adequate for domestic use and so it subsided into that market. The station itself consisted of a series of concentric loops four or five in total on which the coal trains were marshalled and from which radiated a series of spurs to serve the various industrial sites. The most notable of these spurs was probably that which ran up Slater's Incline. From its base which is now below the surface of Kielder Water to Bank Top and beyond to Far Colliery was a distance of perhaps two miles and it was worked by a mixture of horses and gravity. To support the various workings villages were required to accommodate the miners and their families. One such was established at Bank Top, and another at Far Colliery, that at Bank Top was quite a sophisticated affair with its own shop, a chapel and even its own school. The houses at Bank Top were demolished as recently as the 1950s. The village at Far Colliery was a far more modest affair as befitted its smaller pit.

The station at Plashetts was opened on 2 September 1861 and the first coal from the pit departed on the same day. The passenger platform stood on the down side of the line and accommodated a single storey station building with distinctive round topped windows. Adjoining this station building was a water tower of two storeys similarly fitted with round topped windows. The colliery activity was severely curtailed by the General Strike of 1926 and never recovered, the underground workings seriously deteriorated and when the colliery activities resumed it was with a much reduced workforce of about 20. As a result both passenger and goods traffic declined to such an extent that on 2 January 1956 the station was downgraded to unstaffed halt status and the goods yard, by now without a signal box which had been closed in 1926, and many of its sidings became a public delivery siding. On 15 October 1956 passenger services were withdrawn and on 1 September 1958 goods services succumbed as well.

In 1974 Parliament approved plans for the construction of Britain's largest, by volume, artificial lake, Kielder Water. The station site at Plashetts plus a number of farms and a school were lost beneath the water presumably forever as it steadily rose following the opening of the scheme by Queen Elizabeth II in 1982 though it took a further two years to fill completely. Being above the water level the sites of the former miners' villages together with the entrances to the pits they served remain extant.

After a fairly arduous climb out of the 'Plashetts declivity' on a gradient of 1 in 100 the railway enjoyed easier gradients not steeper than 1 in 1000 on its run toward Lewiefield Halt. Lewiefield Halt was a product of the depression when the British Governent's Ministry of Labour established a number of training camps with the object of re-training long term unemployed ship-building workers and miners. Lewiefield was an example of such camps and Lewiefield

Halt was built to serve it. Opened on 3 July 1933 it was built of timber throughout, including a waiting room and a booking office and closed on 15 October 1956. Lewiefield never possessed any facilities for dealing with freight traffic whatsoever.

The station at Kielder (later Kielder Forest) was, like Falstone, another example of the shelf like characteristics of stations on the Border Counties, being long and narrow. The station was originally opened on 1 January 1862 and closed to passengers on 15 October 1956, and to all traffic on 1 September 1958. Facilities at the station comprised two substantial semi-detached houses and from 1890 a typical stone built signal box affording good views of the running line in both directions. The passenger platform was on the up side of the line in front of the station buildings and on this platform also stood the signal box. This platform originally of some 85 yards was later shortened to 75 yards as a result of a re-organisation of the sidings and the construction of the signal box. At the south end of the passenger platform there was a siding serving a goods loading dock. Opposite the platform was a loop with head-shunts at both ends this was known as 'Tree siding' because of the millions of young trees received here from Aviemore during the planting of Kielder forest. Kielder Station was re-named Kielder Forest on 1 October 1948. Kielder was the first station on the Border Counties' Liddesdale Branch which had been authorised by Parliament on 1 August 1859 and ran from Kielder to Riccarton Junction on the Border Union Railway. On 13 August 1860 the Border Counties Railway had amalgamated with the North British Railway and it was they who provided the finance for this extension.

About 11 miles from Falstone, or 3 miles north of Kielder we come to the isolated station at Deadwater. To the casual observer there appears to be nothing here to justify the existence of a station at this point and it seems that the North British Railway thought along similar lines because a station here was not provided for by the original plans. The first hint of such a thing comes about 1871 when reference is found to Deadwater Foot Crossing evidently a private station for the workers at nearby quarries and limeworks. It seems unlikely to us but nineteenth century accounts tell us that this was a workplace for 200 men in former times. In 1880 Deadwater became a public station the platform was extended, and a single siding provided opposite the platform which was on the up side of the running line. In addition there were a couple of spurs heading off to the nearby quarries. The facilities offered by Deadwater were completed by a single storey station building which in former times was presided over somewhat unusually by a station mistress. The station was downgraded to the status of an unstaffed halt from 19 September 1955 and it lost its freight service the same day. Passenger services were withdrawn on 15 October 1956 as they were on the entire Border Counties Railway thus Deadwater became one of the few stations to have its freight service withdrawn before its passenger service.

Within a mile of Deadwater Station lay a further set of sidings at Meredykes or Muirdykes. These sidings, built to serve a further quarry and limeworks, remained operational until about 1918. Continuing our westward progress the railway crossed Dawstonburn viaduct and entered Saughtree Station. A reader who felt that Deadwater Station epitomised isolation could perhaps be forgiven for not appreciating that Saughtree would exceed the degree of remoteness. Perched high up on the hillside a mile and a half from the clachan it purported to serve and a mile from the farm of the same name this is indeed an isolated spot. Quite why a station was built here at all, particularly as part of the original plan, is a mystery. One theory is that one

Andrew Stavert then the owner of Saughtree Farm asked the North British Railway for such a station for his family and workers in return for his considerable financial support. There is no doubt about his financial support as he was a major shareholder in the Border Union Railway which at the time was building the railway from Newcastleton to Riccarton over some of his land, but research has so far failed to give solid evidence of a request from him for a station at Saughtree. We'll leave the historians to find out the details while we return to Saughtree Station. Perched as it was high above the prevailing ground level this was a tiny station. The passenger platform which was on the down side of the running line was surmounted by two single storey buildings one comprising the waiting room and office, the other the station house. Opposite this platform ran a siding which served a loading dock. Around the middle of the twentieth century train services to Saughtree were suspended as a wartime economy measure on 1 December 1944 only to be restored on 23 August 1948. This restored train service to and from Saughtree however never matched the pre-war service. The new service was only offered on a Monday, a Thursday (market-day in Hawick) and a Saturday and even then the would be travellers were restricted to travelling at 1348 northbound for Riccarton and Hawick, and returning from Hawick to arrive at Saughtree at 1708 meaning just two hours shopping in Hawick.

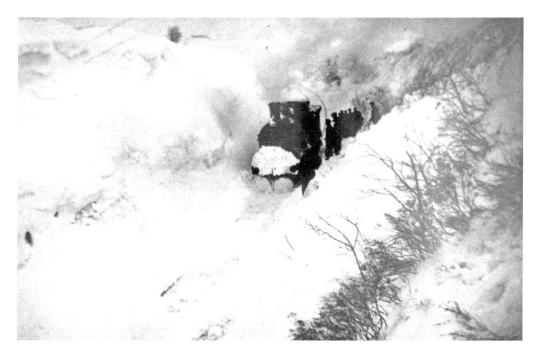

The Border Counties received its fair share of adverse weather - rain, flooding and snow. Here a J27 with a buffer beam-fitted snowplough attempts to clear a blockage in Palmershill Cutting, around a mile south of Riccarton Junction, in the 1940s.

Palmershill cutting is on the long distance walk along the Hawick to Kielder utilising in the most part the trackbed of the Waverley and Border Counties routes. It is now a designated SSSI as a result of the rock strata exposed during the line's construction. (*Roy G. Perkins collection*)

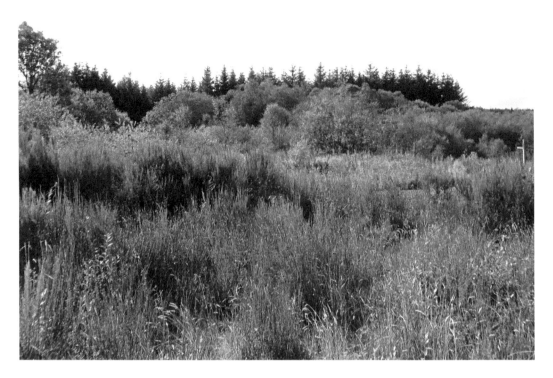

Demolition occurred as the site of Riccarton Junction was cleared for forestry activities and ash recovery. The forestry haul roads do at least define the formation of both lines and broadly follow the track layout through the site. (*Iain MacIntosh*)

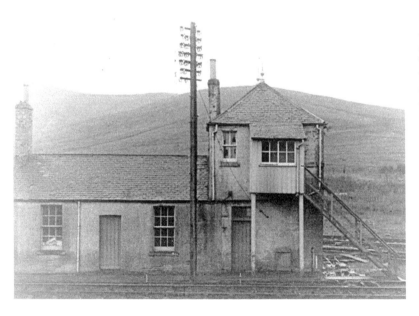

Riccarton South signal box controlled the junction from the Waverley Route onto the BCR at the south end of Riccarton Station. It is viewed here from the coaling stage with the branch running in the foreground. The cottage to the left became the shunters' and coal stage staff's bothy latterly and stood, along with the signal box, into the late 1970s.
(*Roy G. Perkins*)

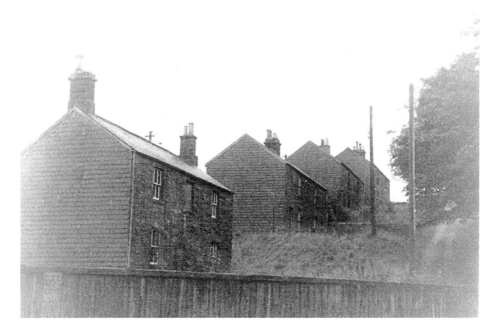

The eight semi-detached houses of Store Brae display the protective slate gable ends added to help protect the structures at this very exposed north end of the site. These were originally the enginemen's houses and were the first to be demolished as the site's importance reduced following the Border Counties' closure. The roofs were first to go, in 1965, with the buildings being demolished by 1966/67. (*Roy G. Perkins*)

The bottom of Store Brae today with the area returning to nature. Some evidence of the railway exists, with the rotting remains of the sleeper deflection fence running along the loop lines site, the walls of the Station Master's house still standing in the trees to the right, and the grey cupboard that contained the weigh machine (now on display 2 miles north at the WRHA headquarters at Whitrope); the gardens of the enginemen's houses still put up a bumper crop of rhubarb every year which a few of us take advantage of. (*Iain MacIntosh*)

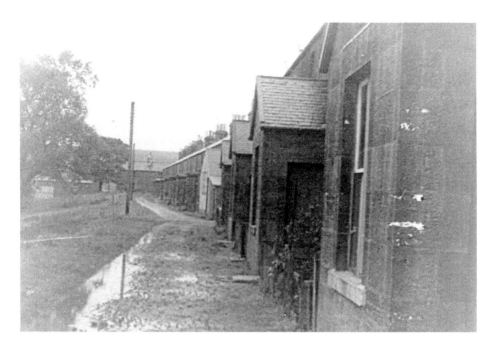

The view north along the top brae with the two blocks of 2 up, 2 down housing that formed the main accommodations at Riccarton. The grey building at the end of the north row was the hall, which was famous locally for its dances with people from the Holm and surrounding areas travelling up by train to attend. (*Roy G. Perkins*)

With the last occupants leaving the village in 1968, the top brae was demolished and the 1963 forestry road was extended; it now bisects the area, as can be seen. (*Iain MacIntosh*)

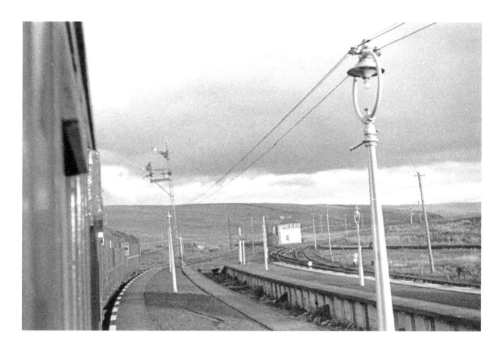

A view from a south-bound train behind a Sulzer type 2 locomotive leaving Riccarton Junction. Ahead lies the South Signal box, with the truncated remains of the Border Counties to its left along with the remains of the coal loading stage. The former south end bay for branch trains remains devoid of track in the centre of the island platform. (*Roy G. Perkins*)

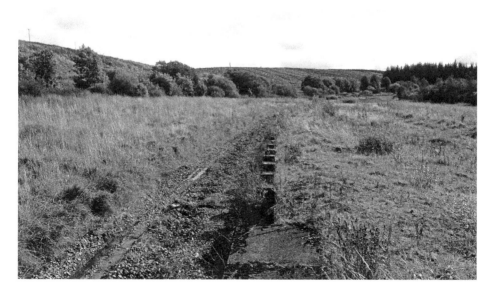

Today the decimated remains of the platform quietly crumble away but with the recent mass felling the landscape has been opened up again. Briefly, at any rate, until the replacement Sitka makes its presence felt. (*Iain MacIntosh*)

Saughtree Station seen from the approach road following closure in 1962. The sparsely populated village it served was a mile away to the south. The trees afforded a little protection in this exposed site. (*Roy G. Perkins*)

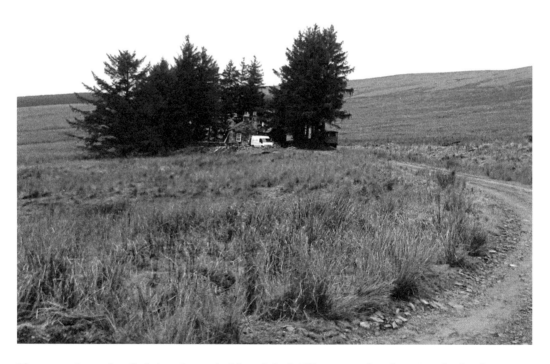

The same view today; little has changed, although Jock Elliot was on hand putting the finishing touches to a very sympathetic extension visible as the new gable behind his van. (*Iain MacIntosh*)

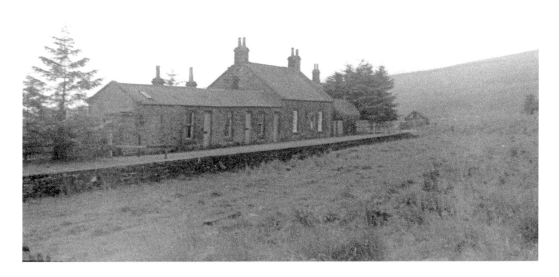

The small but pleasantly proportioned buildings of Saughtree in 1962. Only a single platform and siding existed here for the very meagre traffic receipts the area would provide. (*Roy G. Perkins*)

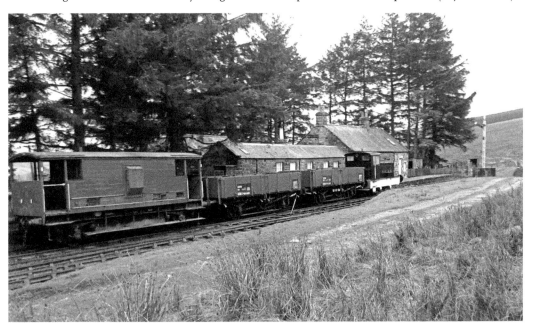

Geoff Mann has restored the buildings beautifully and added sympathetic extensions to bring the buildings to a more comfortable living standard; he has included his own pride and joy: a collection of freight rolling stock and a Ruston mechanical to enjoy on this reinstated section of line. It must be stressed that, although alongside a footpath, this is a private collection on a private site. Geoff is very amenable but I wouldn't seek to annoy him. (*Iain MacIntosh*)

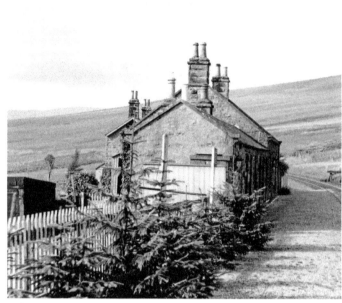

Left: A view north through the station from the rear of a passing freight train with the waiting rooms in the smaller of the buildings and the larger attached Station Master's residence beyond. (*R. W. Lynn*)

Below: The restored buildings and platforms are now dwarfed by the intervening tree growth as the Ruston and its attendant pipe wagons stand alongside. The signal is purely to add to the railway ambience and no signal box was ever provided here in operational days. (*Iain MacIntosh*)

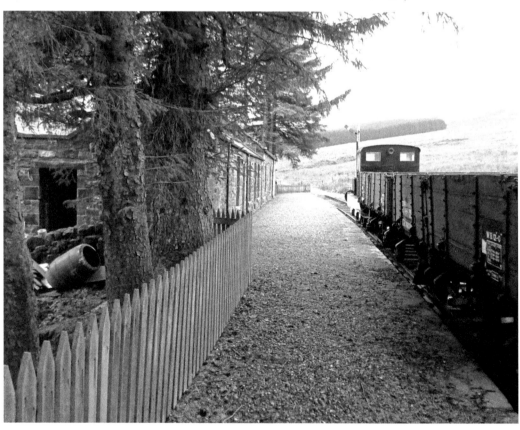

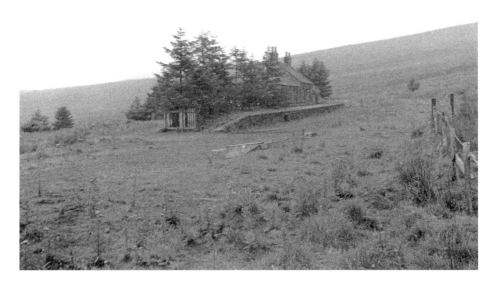

A more general view of the site following closure from Roy's collection; even in the ten years from the previous historic view, the tree growth is considerable. (*Roy G. Perkins*)

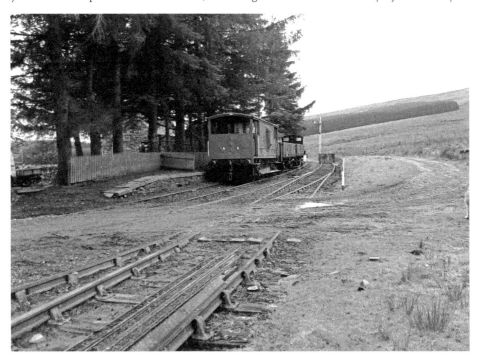

The track layout of the site is more clearly defined here, with the new extension in reclaimed stone visible through the trees. You'd be hard pressed to think this a more recent addition. (*Iain MacIntosh*)

Dawstonburn Viaduct was the first major structure on the way south and lay just to the south of Saughtree Station. Although taken post closure, the double track width is shown despite only a single track ever occupying the deck. (*Roy G. Perkins*)

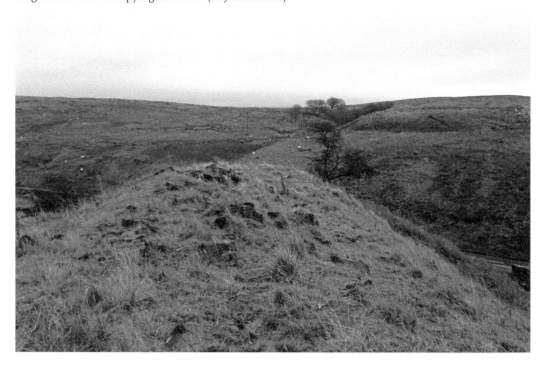

Demolished in the late 1960s or early 1970s, the remnants of the masonry are still to be found piled up along the burn side and around the northern approach embankment. (*Iain MacIntosh*)

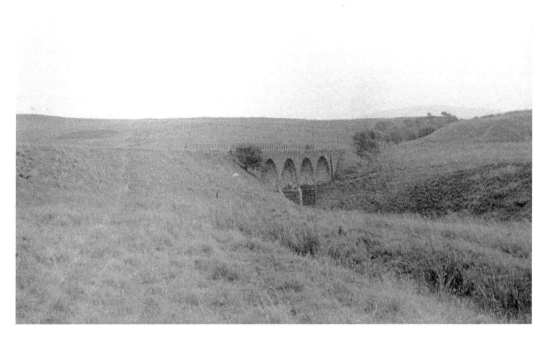

A general view across the south elevation from the station road. (*Roy G. Perkins*)

With viaduct and railways only passing, sheep graze on the wilds of the fell sides. (*Iain MacIntosh*)

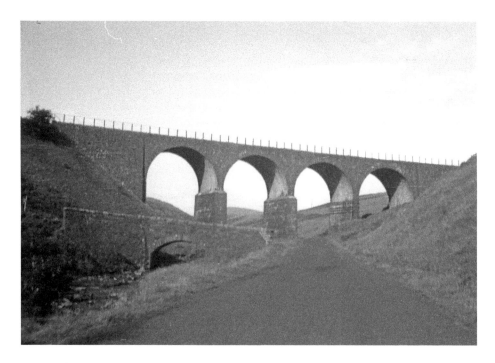

The height and imposing nature of Dawstonburn Viaduct can be seen as it strides across the valley floor. The station was accessed via the bridge in the foreground and the pier strengthening works are notable. (*Roy. G. Perkins*)

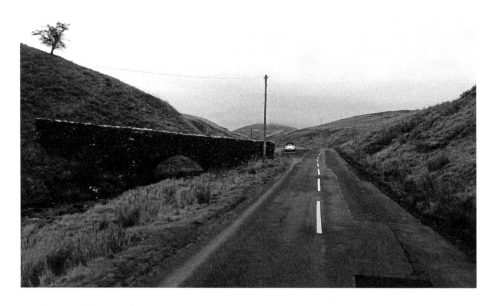

To the casual passer-by, only the hulk of the northern approach embankment and the masonry deposits indicate that any structure of substance existed previously here. (*Iain MacIntosh*)

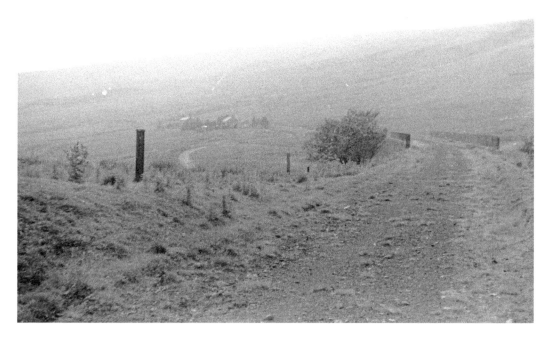

A view north across Dawstonburn which indicates well the desolation and gradient of the climb to Riccarton Junction. (*Roy. G. Perkins*)

Tree growth, further plantations and the loss of the viaduct have changed the scene little in the 51 years between photographs. (*Iain MacIntosh*)

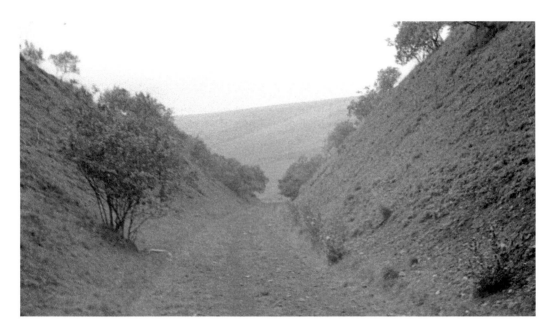

A view through the steeply sided cutting to the south of Saughtree as the line cuts through between the two valleys of Dawstonburn and Liddesdale at Hudshouse Rig. (*Roy G. Perkins*)

The location is still clearly identifiable and is on the Riccarton to Kielder footpath, along the old route. This area also suffered from the weather, with snow drifts blocking the line several times during operating years. It is surprisingly dry given its lack of maintenance over the last 60 years. (*Iain MacIntosh*)

An old occupation bridge stands sentinel as the line returns to an easterly run along Hudshouse Rig, following the course of the Liddel Water. (*Roy G. Perkins*)

Only the removal of the metalwork alters the look of this image, along with the ubiquitous tree growth, although the masonry remains in good order. (*Iain MacIntosh*)

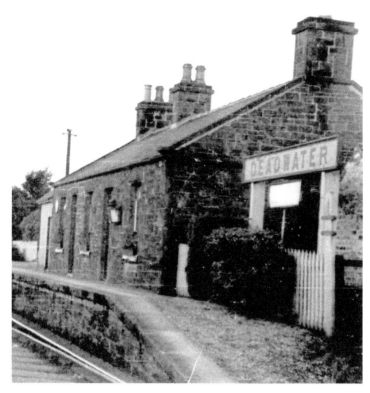

Deadwater station was just south of the Anglo-Scottish Border and, as with Saughtree, supported a very sparse local community. Only one siding was provided for local freight traffic and, like Saughtree, was ground frame operated with no signal box provided. A short distance to the north a private siding ran into the lime kilns at Thorlieshope and Meredykes Sidings. (*R. W. Lynn*)

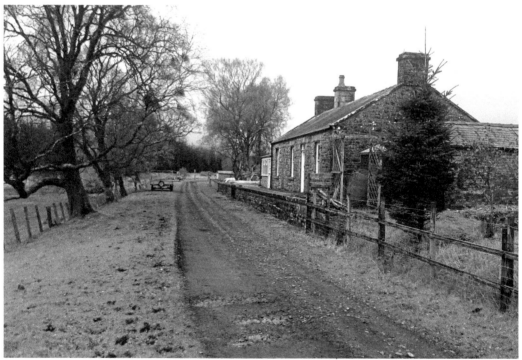

The station is now a private residence and the area is still recognisable from its previous life. (*Iain MacIntosh*)

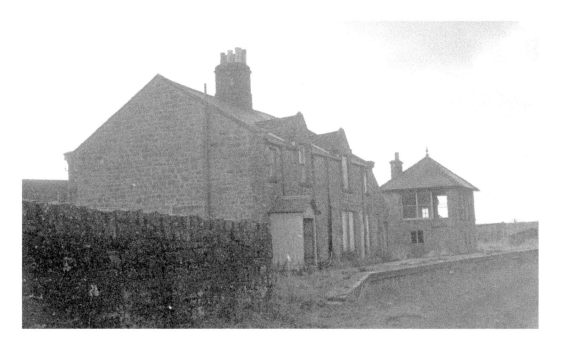

Kielder Forest, as it became known from just plain Kielder in 1948, took on a more substantial role with the coming of the industrial forest from which it took its name when planting commenced in the 1920s. A larger station was built, with a signal box which controlled the first crossing point south from Ricarton Junction. Although devoid of track here in 1962, the size of the facility provided is evident. (*Roy. G. Perkins*)

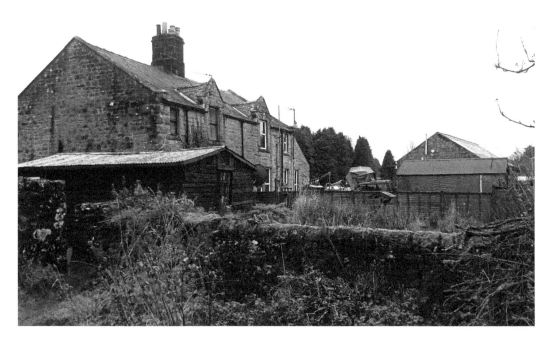

Now two private residences, all aspects of the railway within the immediate vicinity have been swept away. At the time of writing, the closer property is up for sale. (*Iain MacIntosh*)

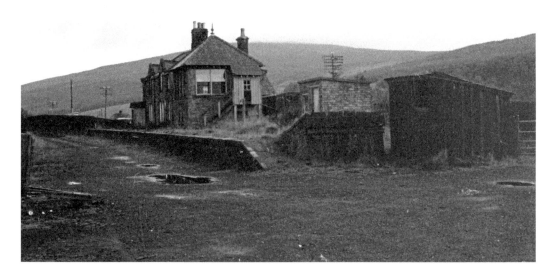

The corresponding view from the south end, with the signal box and block end for the loading dock siding in view. (*Roy G. Perkins*)

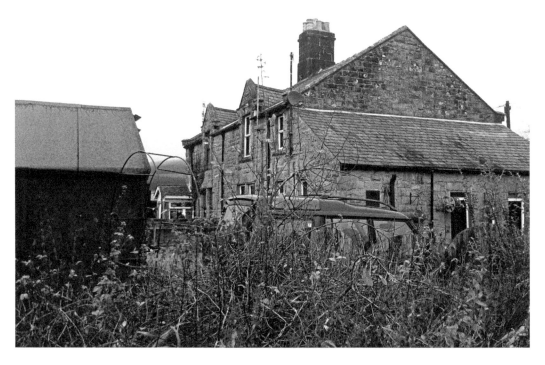

The signal box and yard area are now occupied by a garage and no true comparative can be obtained due to this redevelopment. The box is long demolished. (*Iain MacIntosh*)

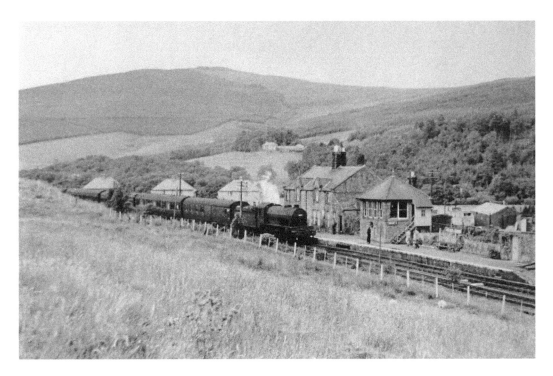

A view of Kielder station in traffic with a Hawick to Newcastle service entering the station. The relatively new forestry housing can be seen above the coaches. (*R. W. Lynn*)

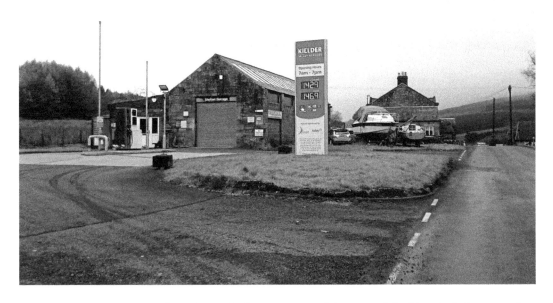

Not a true comparison here due to the boggy nature of the ground the historical view was taken from, but it does clearly illustrate the location's new role. (*Iain MacIntosh*)

The former yard site being utilised for storage in 1962. The line ran beneath the bridge in the background and on to Kielder Viaduct. (*Roy G. Perkins*)

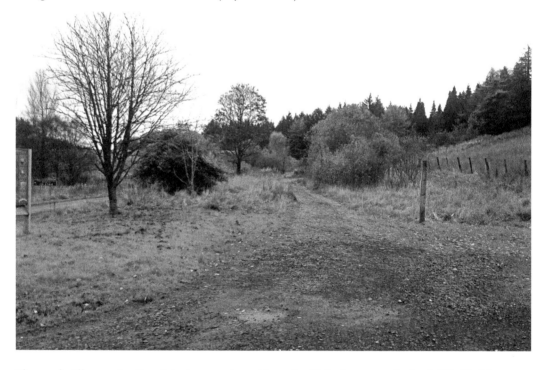

The road still occupies its original route alongside and still doglegs over the back-filled bridge which, with the exception of the north elevation parapet rails, is intact. I have no idea how or why this feature has remained without redevelopment given the heavy forestry traffic. (*Iain MacIntosh*)

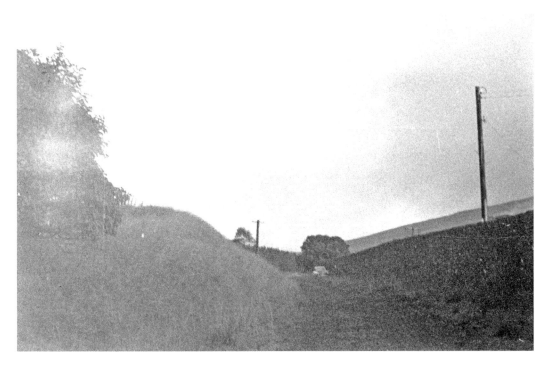

Apologies for the foggy nature of this 51-year-old photo - the print has not stood the test of time too well. This is the formation north of the station heading towards Deadwater. (*Roy G. Perkins*)

Now in use as access, little has changed here with the exception of the sheds. The main road is behind the wall and the passageway to the roadside behind the photographer marks the end of the footpath along the line from near enough Hawick. (*Iain MacIntosh*)

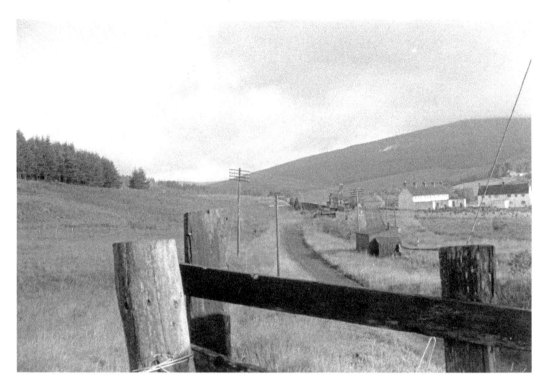

The reverse curve of the track bed and the modern forestry houses are clearly seen here as the route swings north from the south end bridge previously mentioned. (*Roy G. Perkins*)

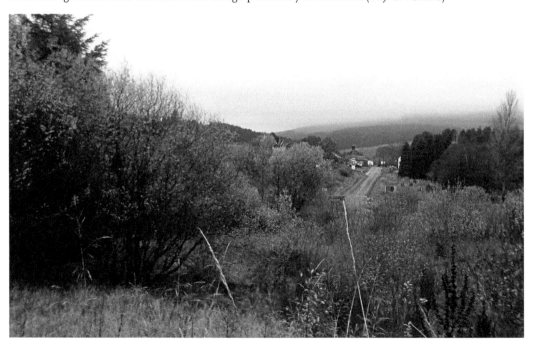

Substantial tree growth has reclaimed the track bed and planned plantations festoon the surrounding fell sides. (*Iain MacIntosh*)

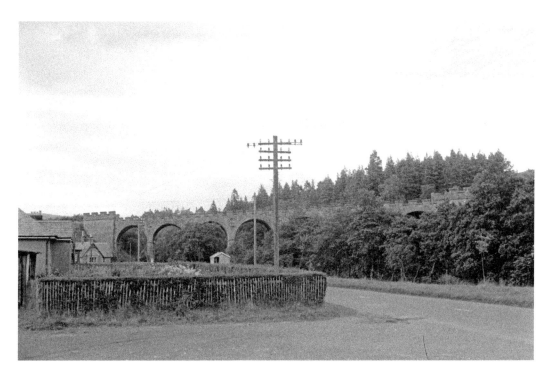

Kielder viaduct was the largest and grandest such structure on the route. Castellated due to its proximity to Kielder Castle and House, it took the line from the west flank of the North Tyne valley to the east flank as the line wound down to Falstone. (*Roy G. Perkins*)

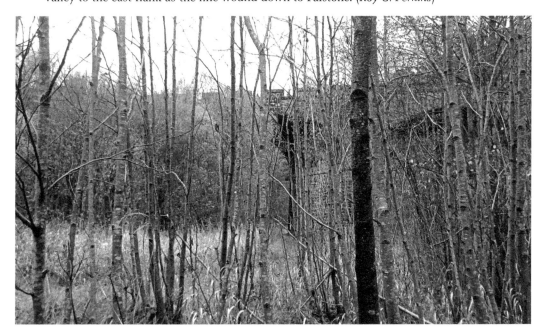

A true comparison is impossible now as a result of the construction of Kielder Water. The northern reservoir, the Bakethin, resulted in the re-routing of the road and one step further back would result in a 'wetting' of the highest order. (*Iain MacIntosh*)

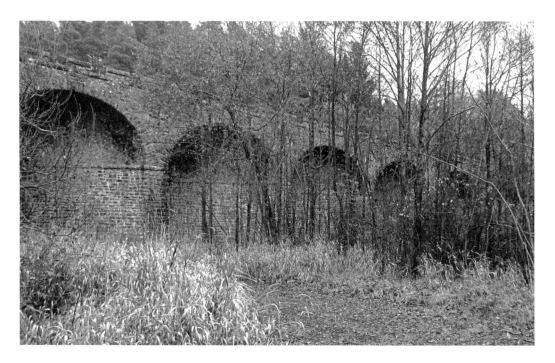

As a result of a threat of demolition, the Northumberland and Newcastle Society acquired the structure and improved its state of disrepair. The viaduct features over the coming pages and is a credit to them and a joy to walk across. This view gets as close as possible to revealing this elevation from the north bank. (*Iain MacIntosh*)

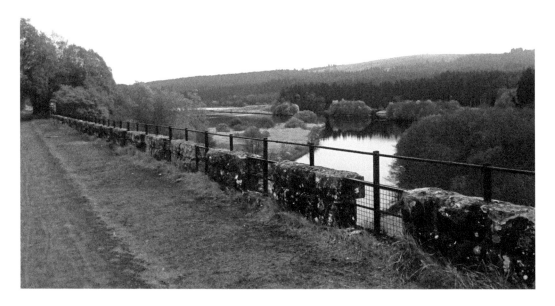

The view from the deck over the autumnal colours and the Bakethin Reservoir reminds you of the beauty of this part of Northumberland. When it's not raining and if you are not being devoured by midges, that is. (*Iain MacIntosh*)

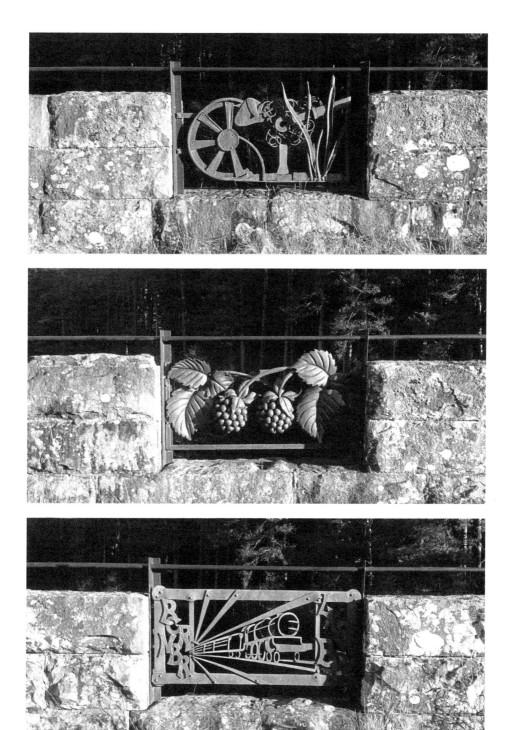

In 2004 the Northumberland and Newcastle Society commissioned a series of sculptures to be added into the castellations of the structure's east parapet.

 These are shown here and on the following page. (*All Iain MacIntosh*)

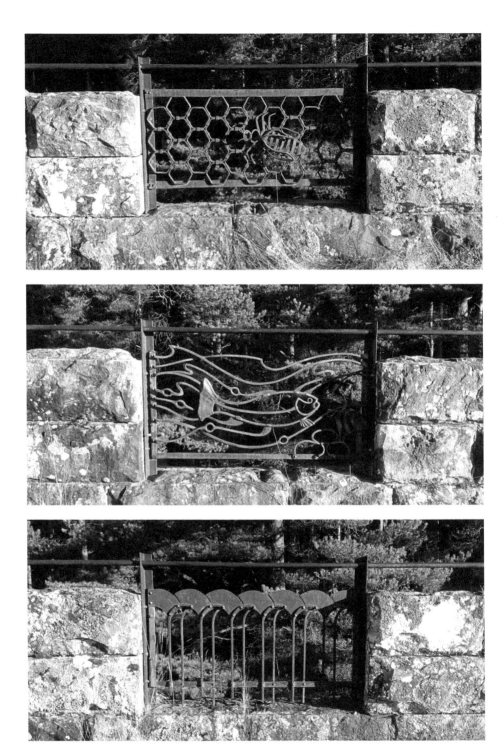

The viaduct now lies on a footpath which runs along the full length of the shore line of both Kielder Water and the Bakethin Reservoir. At 26.5 miles or so it's possibly not for the faint hearted. I can thoroughly recommend it although, as you will see, I was extremely lucky with the weather on my November visits. (*Iain MacIntosh*)

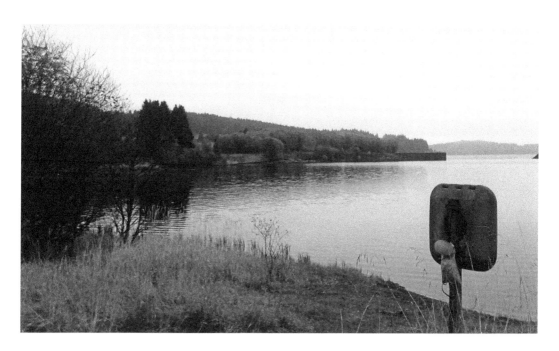

Over several of the following pages I have indicated where the route may still be seen peeking out from its watery grave. This photograph is at the northernmost limit. Originally an embankment made its way over to the built-up land ahead, but it has been cleared, presumably for material to be used in the dam. The spit of land is the weir/dam wall of the Bakethin Reservoir, defining Kielder Water as in fact being two bodies of water. (*Iain MacIntosh*)

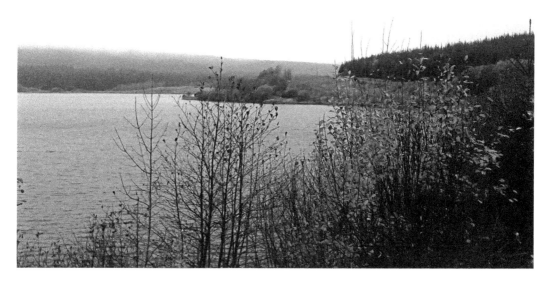

The view north from Bakethin dam wall where the embankment would have cut through the spit of natural land on the way to Lewiefield Halt. The line came through a cutting by the trees in the centre distance. (*Iain MacIntosh*)

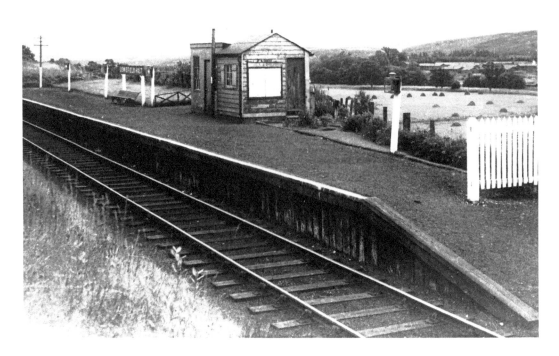

Lewiefield Halt was built to serve Gowanburn and the surrounding farmsteads along with the government training camp seen in the rear of the historic view. The halt had a 23-year life span, opening in 1933 and closing to passengers with the line in 1956. (*R. W. Lynn*)

The site of Lewiefield Halt is all but obscured by trees despite the formation climbing out of the water at this point, albeit briefly. (*Iain MacIntosh*)

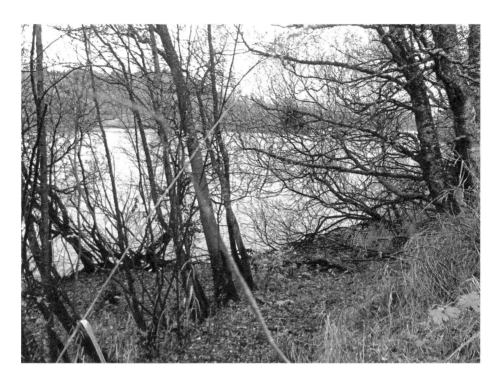

The track bed lifts itself out of the cold waters to the north of Lewiefield as it climbs to cut through the flank of land at Gowanburn. (*Iain MacIntosh*)

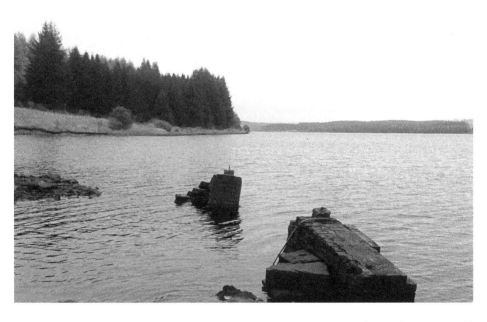

The heavily washed embankment disappears back into the depths to the south of Lewiefield Halt, a total distance of a quarter mile in the dry. The bridge remains originally gave access to the platform from Gowanburn Farm, and also to the training camp across the river. Parts of the formation heading south from here can be seen in the shallows along with the odd masonry abutment of under bridges crumbling into the water. (*Iain MacIntosh*)

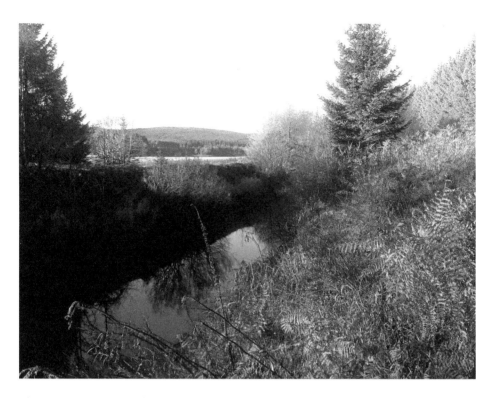

The last opportunity to glimpse the route is afforded just over a mile south from Lewiefield as the cutting does its best to become a canal. Only a drought allows further exploration of the remains of the route from here south. The top view is to the north, with the bottom being the corresponding southerly view. (*Iain MacIntosh*)

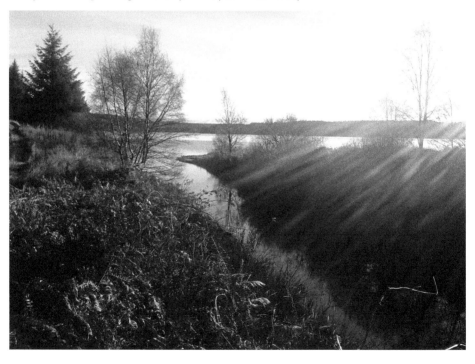

The view from the bottom of the Plashetts incline, with the deserted route curving away to the south. The spoil bings of some of the Plashetts mine workings can be seen among the recently planted fell sides. (*Roy G. Perkins*)

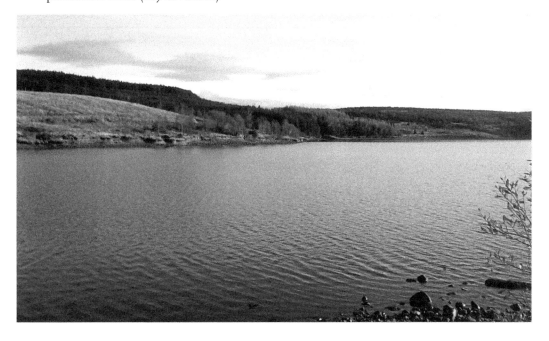

As close a contemporary view as possible here, with the flooding of the valley preventing a closer view. Plashetts incline climbs out the water on the far bank, defined by a concrete jetty. (*Iain MacIntosh*)

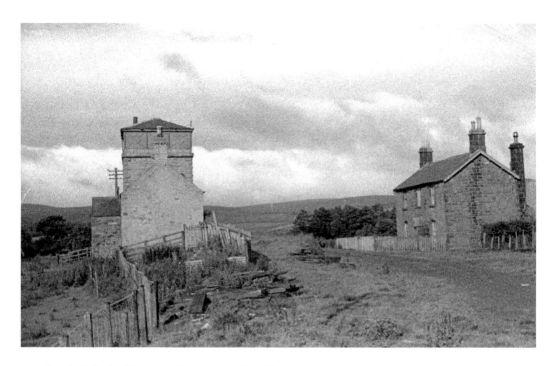

The detail of the buildings can be seen in the following views taken by Roy in 1962. The track had been lifted barely 4 years previously but some of the buildings still saw use through to the construction and flooding from 1975 to 1979. (*Roy G. Perkins*)

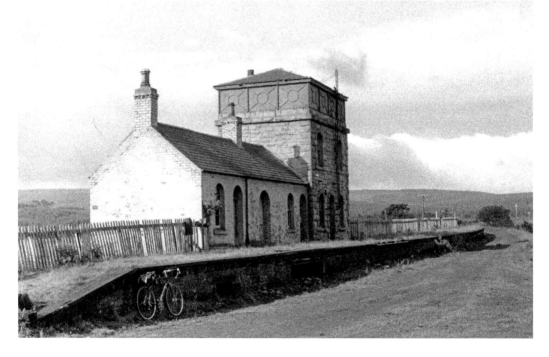

A closer view of the platform buildings and water tower, along with a younger Roy's afternoon transport parked in the platform. (*Roy G. Perkins*)

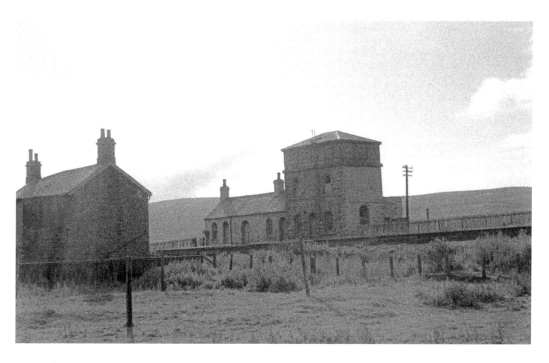

The station buildings seen from the north. (*Roy G. Perkins*)

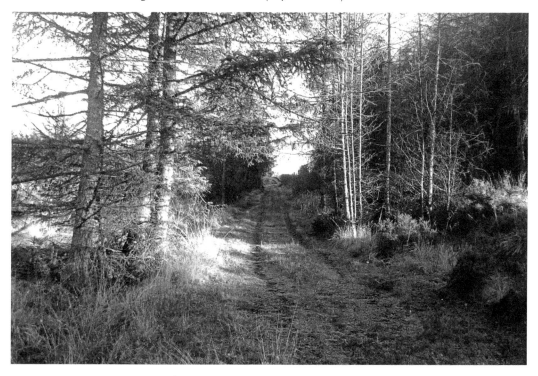

Slightly out of sequence due to the book's layout, The Plashetts incline is seen climbing away to Near Colliery from the lake side path. Information boards are provided here to explain the area's former story and industry. (*Iain MacIntosh*)

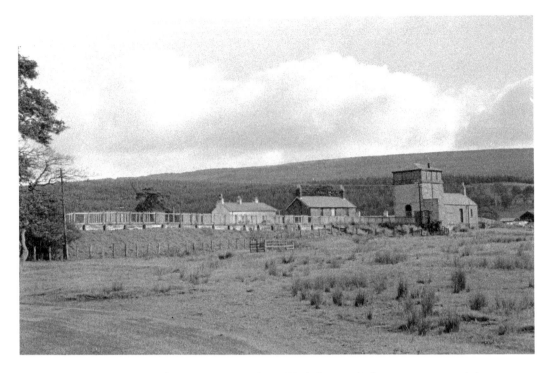

The rear of the platform buildings seen from the fields below, with the Station Master's house and other village properties beyond. (*Roy G. Perkins*)

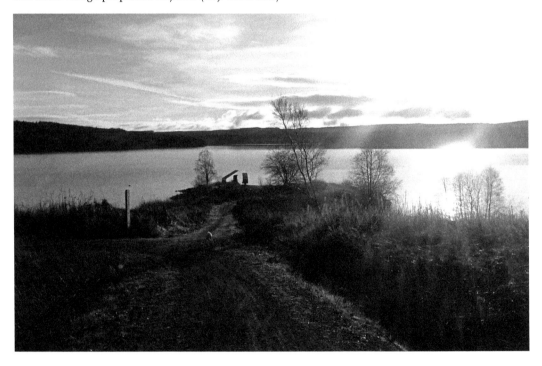

The view today from above the village site, taken roughly from the fell side above the cottages in the historic view. (*Iain MacIntosh*)

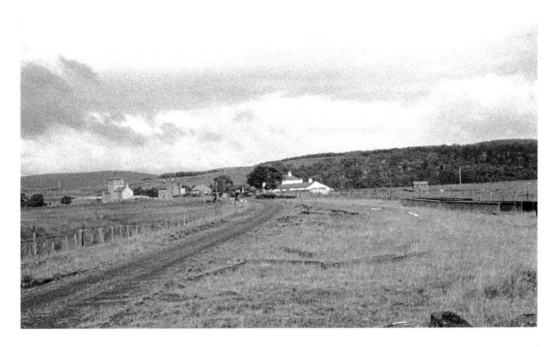

The view north from the exchange sidings below the incline at Plashetts. Sizable remains of industrial relics rust away with no further role to perform. (*Roy G. Perkins*)

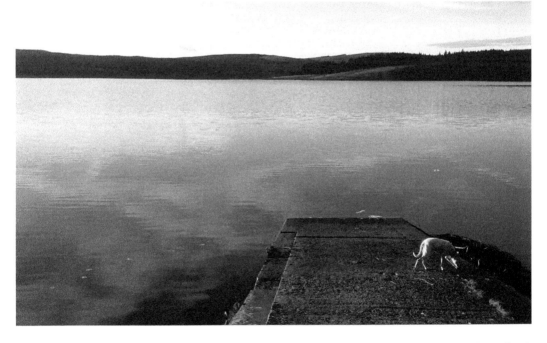

The closest possible view available now is from the base of the jetty which forms the incline's meeting point with the water. The trees directly ahead match those to the rear of the buildings in the historic image. Surprisingly, this reveals that Plashetts station and house would only be approximately 40 to 50 feet deep at this point, not that Abi looks the slightest bit interested as she route learns the foreshore. (*Iain MacIntosh*)

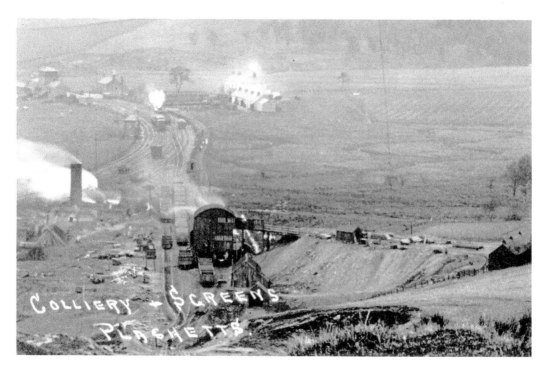

A view from about the midpoint of the incline towards the village, workshops and sidings below. (*R. W. Lynn*)

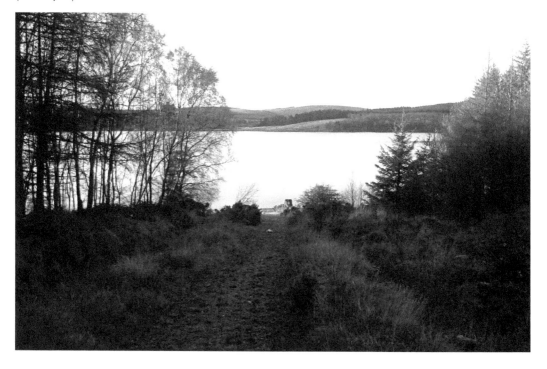

The same location today from the waterside path and information boards provided. I assure you the weather isn't always this kind. (*Iain MacIntosh*)

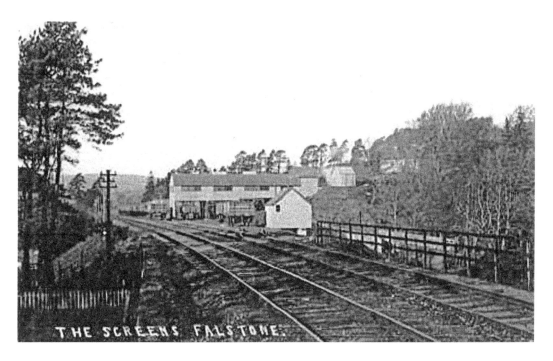

Just to the north of Falstone village was the Falstone Coal Company's mines at Hawkhope. The mines varied in productivity, suffering flooding, and finally closed in the late 1940s. (*R. W. Lynn*)

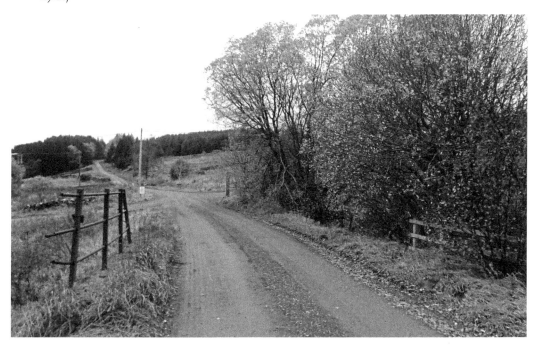

This is my best guess as to the site of the former colliery; it was demolished 60 or so years ago. The bridge leads over a burn at Hawkhope and the landscape quickly changes due to the presence of Kielder dam, which runs to the left from the trees on the fell side. (*Iain MacIntosh*)

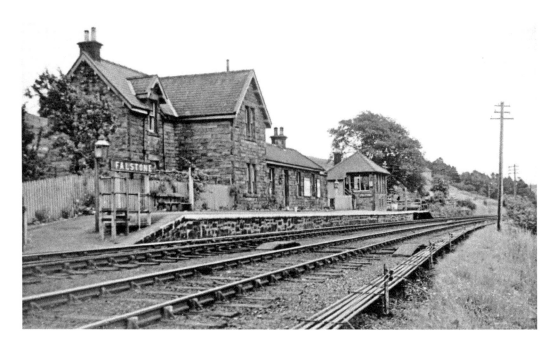

Falstone Station was situated on the next crossing point south from Kielder and the tokens were exchanged here for the sections north to Kielder and south to Bellingham respectively. It has to be said that it was quite large for the village it served, although Falstone was one of the more sizable communities in the North Tyne Valley. (*R. W. Lynn*)

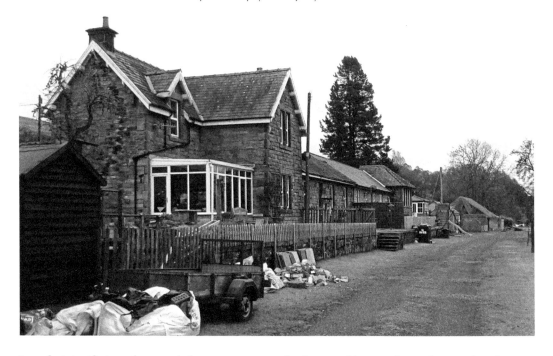

Largely intact but vastly extended to serve as several private residences, the station survives in its commanding position looking across the valley floor. Even the signalman's token exchange platform is still extant, poking out from behind the garden shed. (*Iain MacIntosh*)

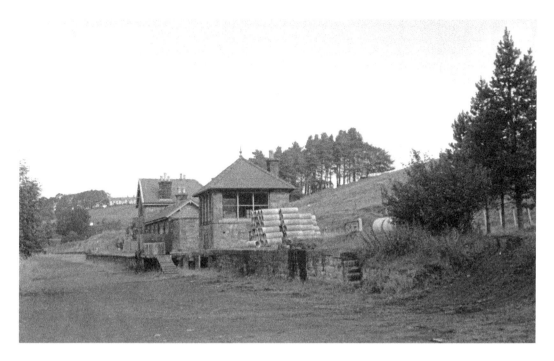

The station from the south following closure in 1962, showing everything except the track and associated infrastructure still in place. (*Roy G. Perkins*)

Further construction works for dwellings are currently taking place in the former yard but the station stands intact and has been extended beyond. (*Iain MacIntosh*)

Looking north through the north end yard. The loop ran in from the left with its head shunt beyond, the main line through the centre and a siding ran in front of the grey box (I assume for a weigh machine) on the right. (*Roy G. Perkins*)

The area has now reverted to nature but is managed and forms a nice private idyll for the owner. (*Iain MacIntosh*)

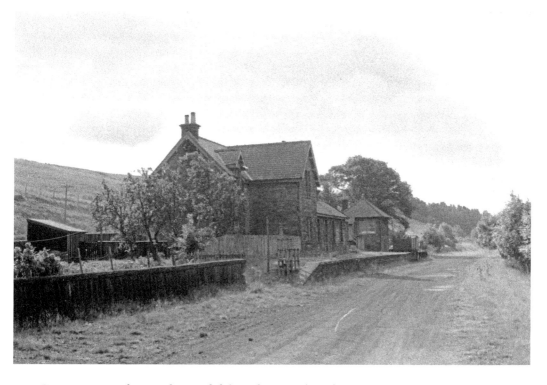

Two views at Falstone after track lifting from Roy's archive of 1962. *Above:* The main station buildings remain unaltered from their operational days. *Below:* The view south through the south end yard and loading dock. (*Roy G. Perkins*)

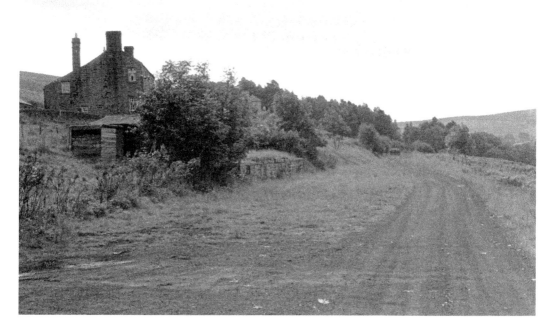

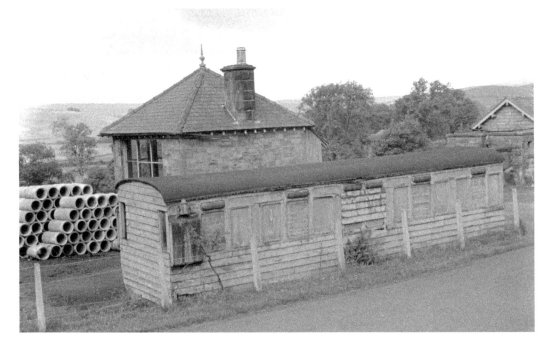

The rear of the signal box and waiting room shows a grounded coach in use for storage alongside the road to Donkleywood. The guttering of the signal box will have to wait a while longer for attention. (*Roy G. Perkins*)

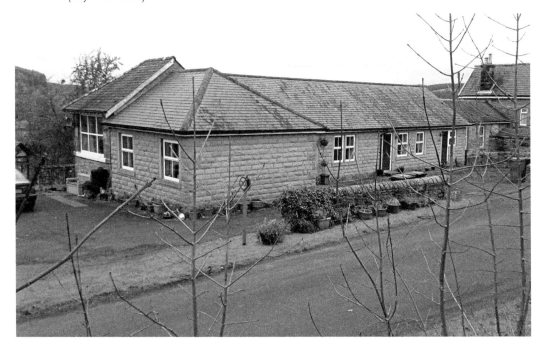

The substantial extensions to the original structures are plain to see. The signal box now forms a cottage annex, a new building stands between it and the waiting room as a second dwelling, the waiting room itself is a third and finally the station building at the end. (*Iain MacIntosh*)

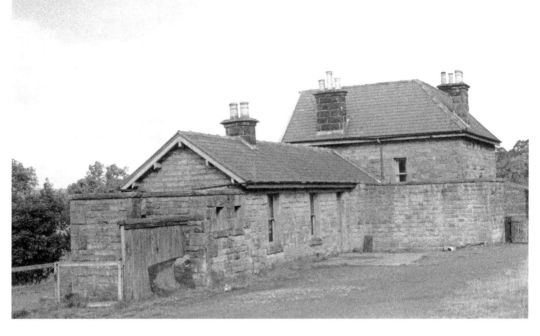

A final view of Falstone Station building showing the decorative stonework employed in its construction. (*Roy G. Perkins*)

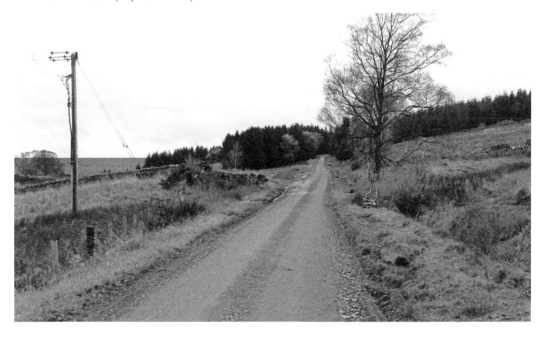

Slightly out of sequence to allow for the previous pages, the view from Hawkhope to Kielder dam demonstrates well the infilling of the cutting and the massive earthworks of the dam construction itself. The track ran to the left, alongside the dry stone wall, and into the now altered landscape and plantation beyond. (*Iain MacIntosh*)

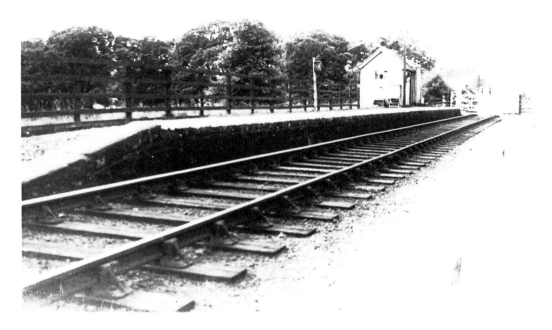

Thorneyburn Station was a single platform located by a level crossing. With only a few houses and farms around the local area, one can only assume that the presence of the road was the reason for construction. Only selected services stopped at the station. (*R. W. Lynn*)

A permanent way hut quietly falls apart opposite the bank of the former platform, the timbers of which have already rotted away. The level crossing gates and former crossing keeper's cottage stand beyond in good order. (*Iain MacIntosh*)

Tarset was built near to the remains of Tarset Castle and served Tarset Hall, taking its name from both. The community of Lanehead was the closest village, being half a mile away. The historic view from 1962 illustrates the single platform, although devoid of track. A single siding was provided for freight traffic. (*Roy G. Perkins*)

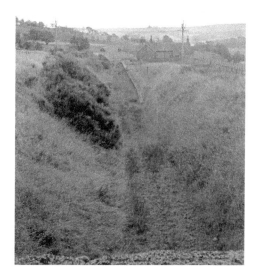

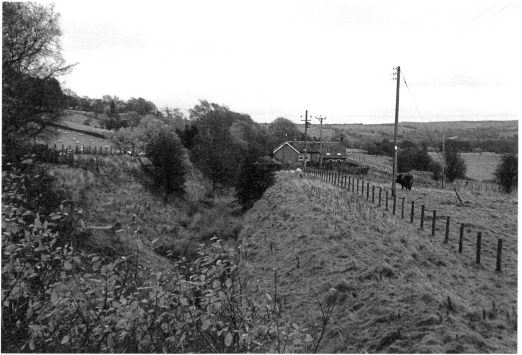

The contemporary view demonstrates little in the way of change to the station buildings, save for rendering and the tree growth within the private residences' gardens. (*Iain MacIntosh*)

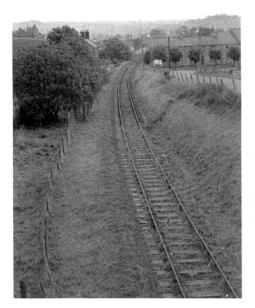

What remains of the line strides north, albeit briefly, from Bellingham. The former home signal stands aloft still, however. By this date the town was only accessible from the Wansbeck route, coming across country from Morpeth and reversing at Reedsmouth 2 miles to the south. Officially only open to goods traffic, specials and passenger traffic still came in for the large farm markets held in the town. (*Roy G. Perkins*)

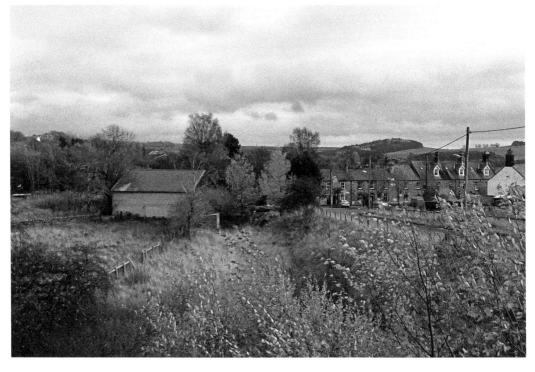

The track bed has returned to nature and a workshop encroaches on the formation but otherwise little has changed here. (*Iain MacIntosh*)

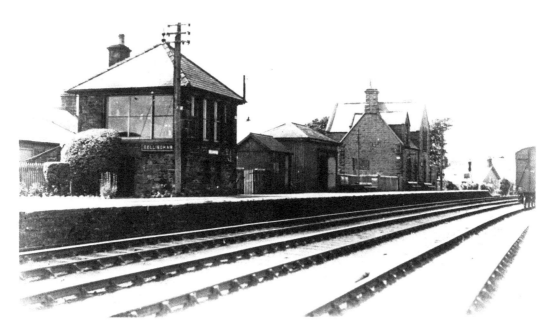

The main station buildings and trackside at Bellingham. The large yard spread out from opposite the main buildings to the south and generated a reasonable amount of traffic for the line. The loop runs through the centre and there was a further loop for the general merchandise van to assist in marshalling traffic. (*R. W. Lynn*)

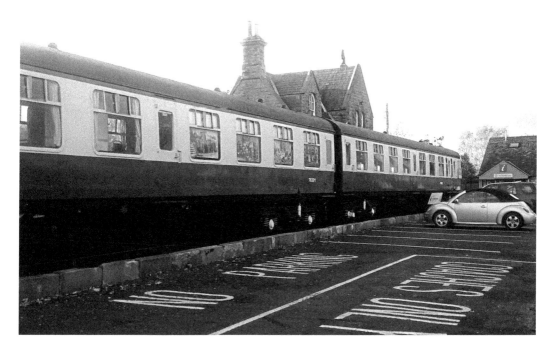

The station site is now part council yard and parking for Bellingham Heritage Centre, which occupies the building beyond the coaches. The former southern unit coaches now form a café and interpretation centre and is managed by the Heritage Centre. (*Iain MacIntosh*)

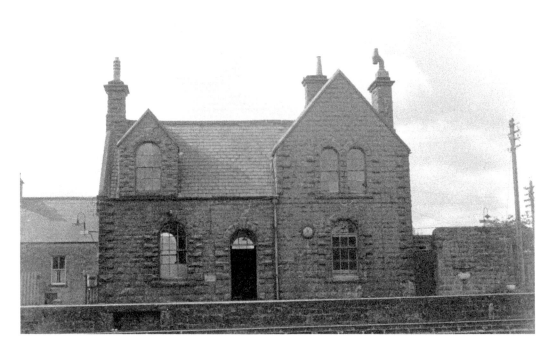

The main 3-storey station building stands alongside the platform. Built of dressed stone, the passenger entrance was below at street level, with the first floor being at platform level. (*Roy G. Perkins*)

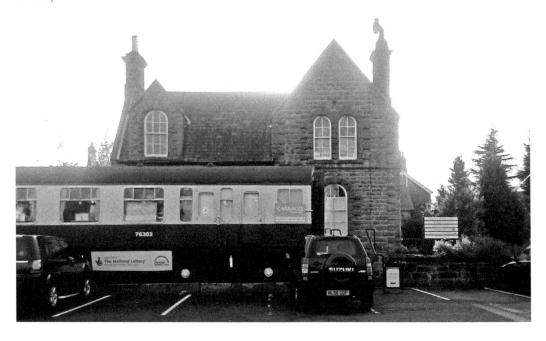

The station building has benefited from being cleaned and presents itself very well, with the coaches placed in the platform and repainted in the attractive 'blood and custard' livery of the 1950s. (*Iain MacIntosh*)

The roadside elevation reveals all three storeys of the building, the original passenger entrance being the door below the street side gable. (*Roy G. Perkins*)

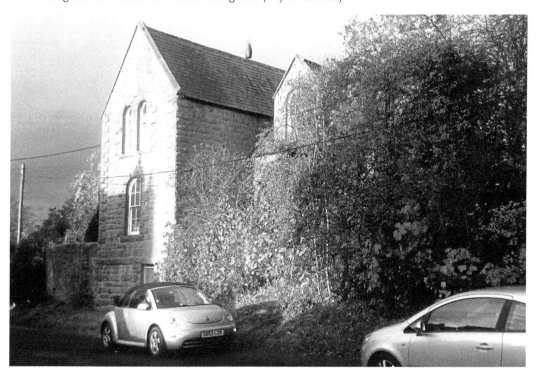

The main building stands intact and unaltered. The access to Bellingham Heritage Centre is through the former goods yard gates on the other side of the complex. (*Iain MacIntosh*)

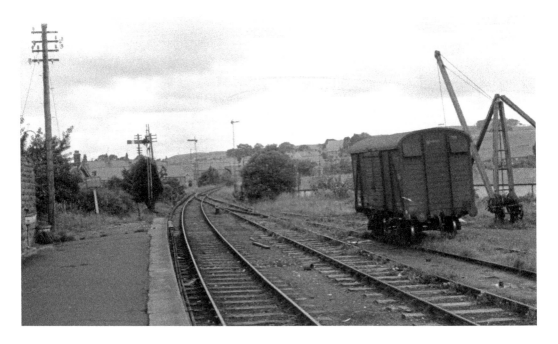

The view north from the platform end towards Tarset and Falstone. Part of Roy's survey from 1962, traffic is still in evidence in the yard in this image but would cease in 12 months time. (*Roy G. Perkins*)

The corresponding view shows the Heritage Centre building now occupying the route north. In rear of the building the over bridge has been demolished to create more headroom for wagon traffic on the main road. (*Iain MacIntosh*)

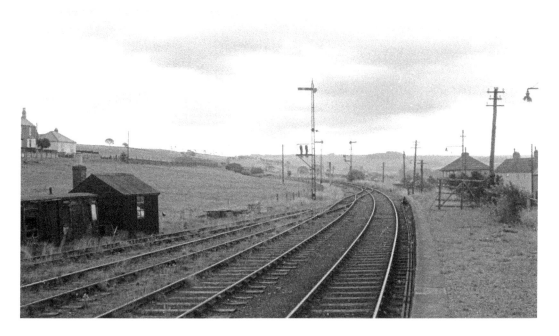

The view south shows the gentle sweep of the route to Reedsmouth, the next section, and the goods yard throat. The railhead bares signs of recent use, indicating that goods traffic was still using the line and recently in terms of Roy's visit. (*Roy G. Perkins*)

It is not possible to get to the exact spot for a contemporary view as the council yard and housing now occupy the site beyond the steel fence. Remarkably, however, the stone building poking out from behind the green container is the base of the signal box, now in new usage. (*Iain MacIntosh*)

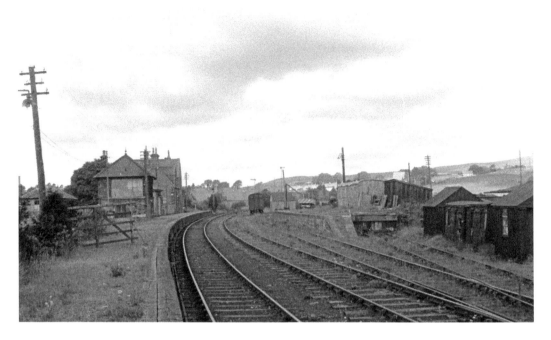

A general view north through the station with the overgrown goods yard to the right with one van in residence. (*Roy G. Perkins*)

Again, the council yard prohibits a true contemporary photograph but displays the rather fortunate double coach length of the remaining platform and site. (*Iain MacIntosh*)

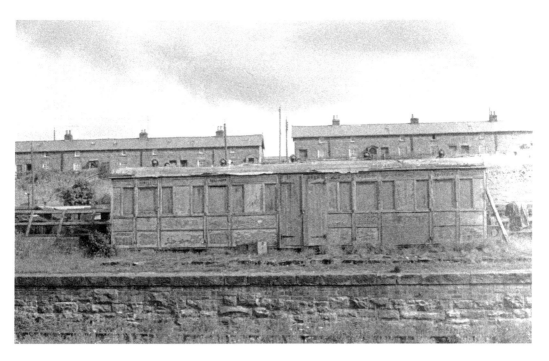

A grounded coach body supplies storage on the loading dock. (*Roy G. Perkins*)

Beyond the council yard, substantial redevelopment with housing has taken place. The row of houses in the rear just ties the locations together although this is actually further along from the station than the historical view. (*Iain MacIntosh*)

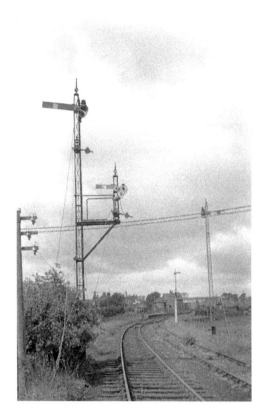

The down home signal and yard signal stand to the south end of Bellingham yard. These signals would still be in use but the down distant would have been downgraded to fixed with the closure of the route north. (*Roy G. Perkins*)

No signs of this end of Bellingham yard remain today, with new housing occupying the site. (*Iain MacIntosh*)

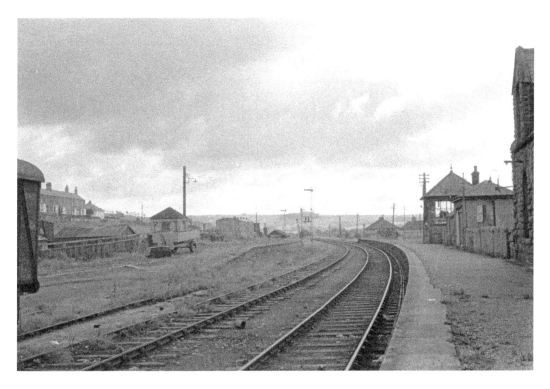

The general view south through the station in 1962, with a similar viewpoint from 2013 below. (*Roy G. Perkins, Iain MacIntosh*)

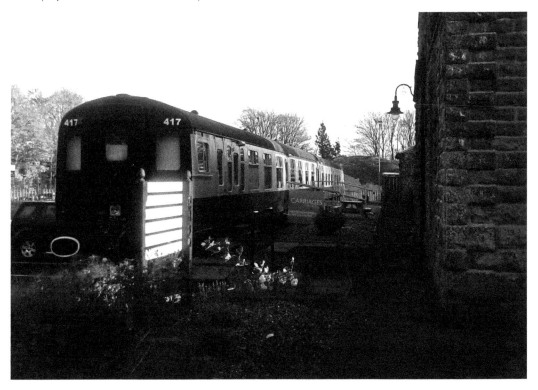

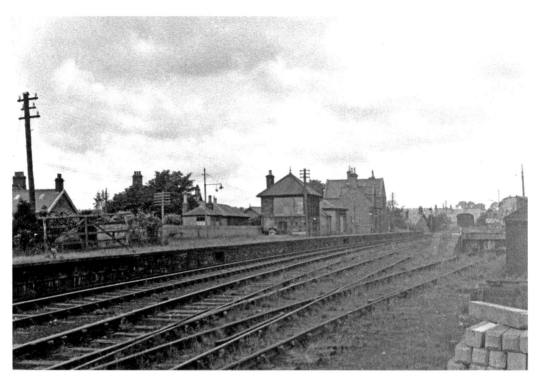

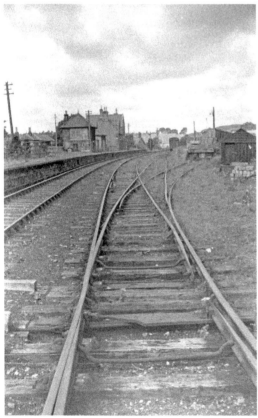

A series of final views at Bellingham with the station complex (*above*) and detail of the yard pointwork and the end loading dock (*left*).

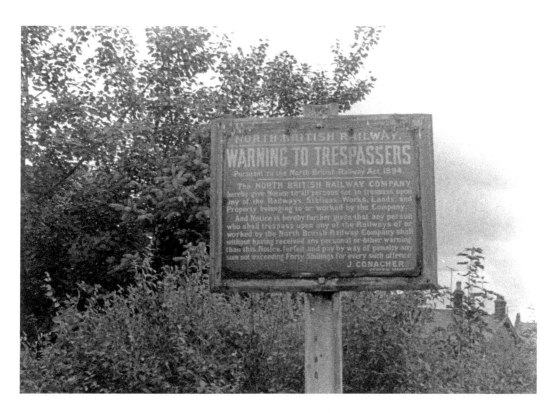

Period warning sign against trespass (*above*);and finally the rear of the storage shed and signal box (*below*).

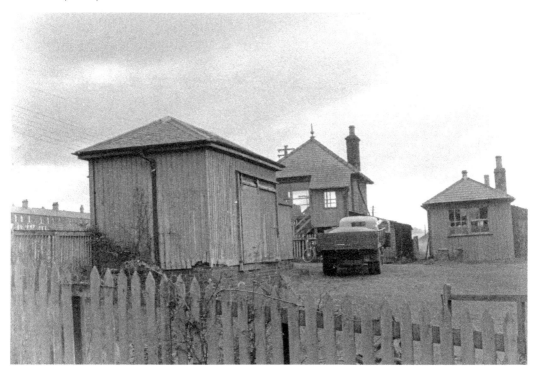

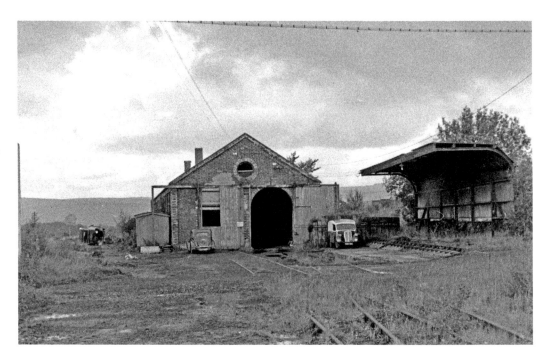

The shed building and coaling stage at Reedsmouth provided Locomotives for local and freight traffic on the former Border Counties and Wansbeck routes. The locomotive that fell into the Tay when the Tay Bridge collapsed was shedded here upon its recovery and return to traffic. The Scottish footplate crews considered it an unlucky loco and refused to drive it, their English colleagues reputedly having no such issues. (*Roy G. Perkins*)

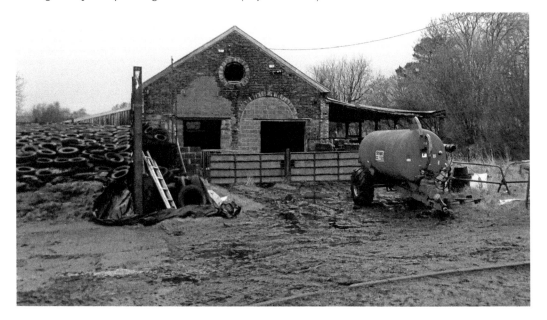

Looking a little sorry for itself, the shed still stands in agricultural use. A footpath now runs along the formation here but due to the cattle and drainage damage it's distinctly a wellies affair. (*Iain MacIntosh*)

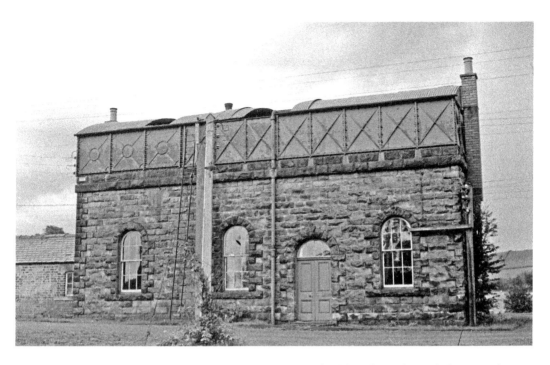

The large water tower stands atop of the main station building, heated from below in inclement weather. Located on the main island platform, it was approached from Station Road and the village.

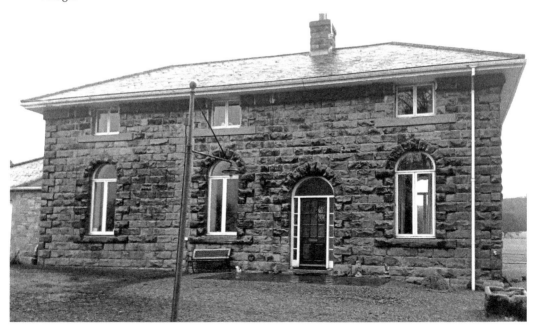

The water tower and station building have now been converted into a private residence and it is with great thanks to and not a little bemusement from the owner and that of the signal box that I was able to obtain all the photographs here without getting incredibly muddy or chased by cows. (*Iain MacIntosh*)

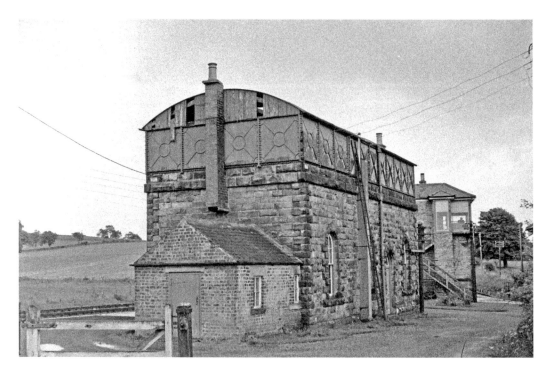

The relationship between the station building and the signal box can be seen from Station Road as the triangular site is approached. The box needed to be so lofty to afford a view for the signalman over the water tower and footbridge of approaching services. (*Roy G. Perkins*)

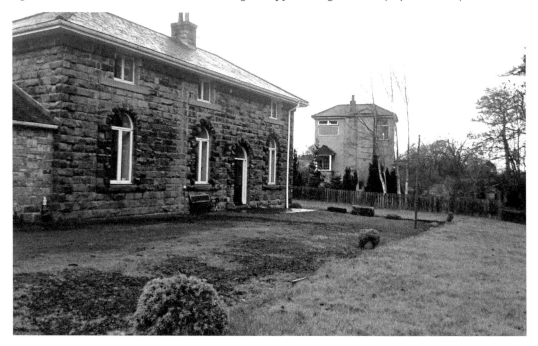

The contemporary view is taken from a slightly different perspective due to trees in the garden of the former station building. (*Iain MacIntosh*)

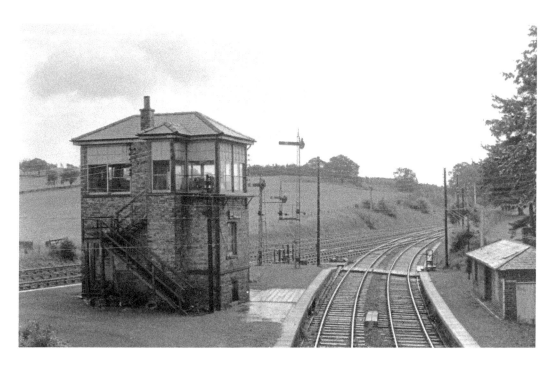

The commanding signal box replaced a lower original when redevelopment works were undertaken here; these included the provision of the footbridge that this historic view is taken from. It itself replaced a former underpass that was abandoned upon its commissioning. (*Roy G. Perkins*)

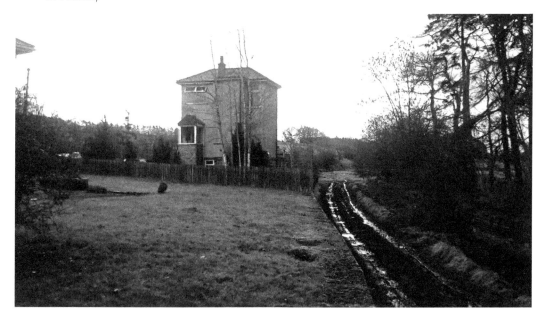

The footbridge was dismantled some time after closure and after many years of dereliction the signal box was converted into a dwelling. The slightly ungainly looks are not a result of the owners but of the planning authorities granting its change of use. Aesthetics are not the preserve of the suits in planning unfortunately. (*Iain MacIntosh*)

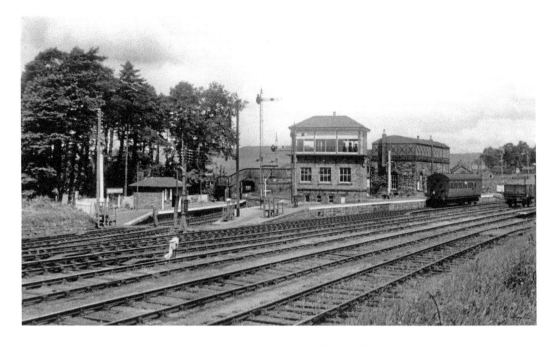

A general view of the site from the south end junction shows off the converging triangular nature of the location, demonstrating well the need for such a tall signal box. It must have been a pain exchanging tokens for the signalman, though all those stairs would have kept him fit. (*Roy G. Perkins*)

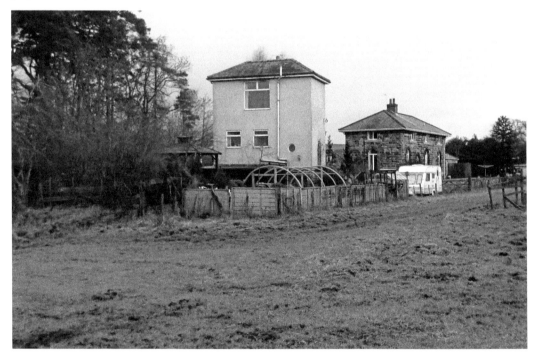

Today all the tracks are gone and the track bed now carries cattle on foot and not by wagon. The two buildings look rather at odds with the fields now surrounding them. (*Iain MacIntosh*)

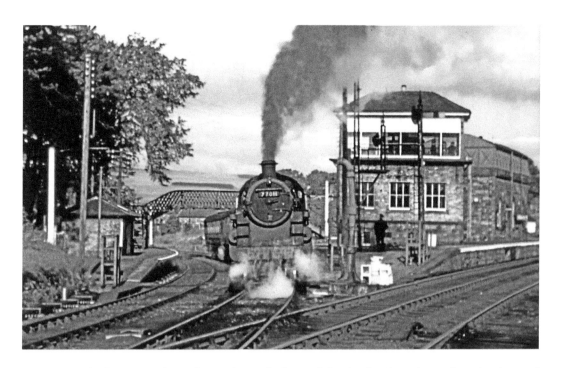

A standard 3mt stands in the Hexham platform of the Border Counties and awaits the road forward. None of these locomotives made it to preservation and a group run by a dear friend of the authors is aiming to build a new one. Further information can be found at www.77021.org and we wish them the best of luck as well as helping where we can. (*77021 Loco Group*)

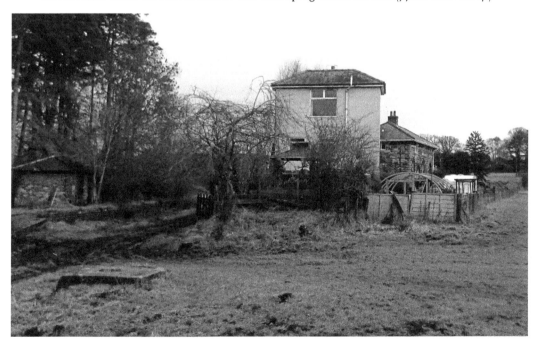

The base of the water column sits in the foreground, with the Riccarton platform waiting shelter still standing and the other buildings as previously described. (*Iain MacIntosh*)

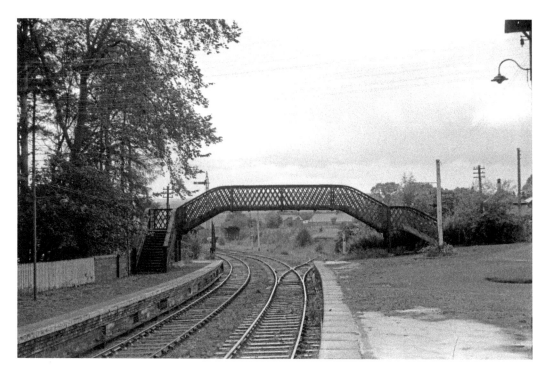

The shed can just be seen through the attractive footbridge at the north end of the Border Counties platforms. (*Roy G. Perkins*)

The muddy footpath leads through the platforms and the shed still stands in the distance. You can see my reasons for not venturing along the path and seeking permission of the respective owners to access their land. (*Iain MacIntosh*)

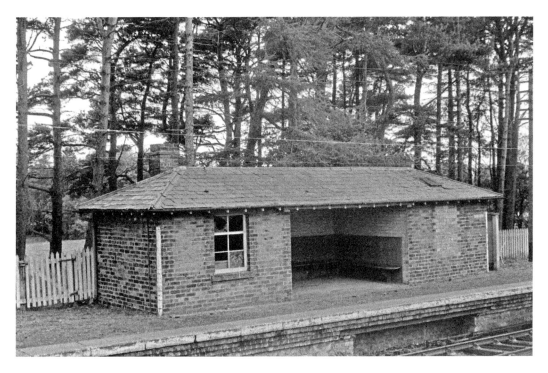

The very basic but attractive brick waiting shelter of the Riccarton platform hides in the shade of the trees behind. (*Roy G. Perkins*)

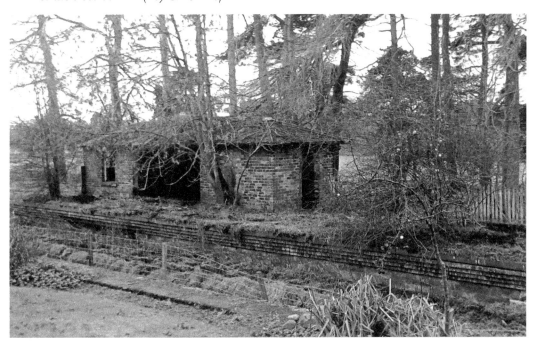

Although still intact and therefore clearly well built, with no maintenance the shelter now hides in the trees rather than just in their shade, which explains the altered perspective of the contemporary photograph. (*Iain MacIntosh*)

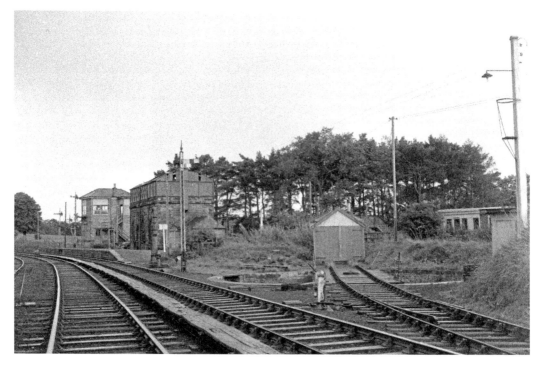

The turntable was tucked in at the north end of the Morpeth platform with a siding and the inspection trolley shed ahead of it. The loops on the Wansbeck side are apparent. (*Roy G. Perkins*)

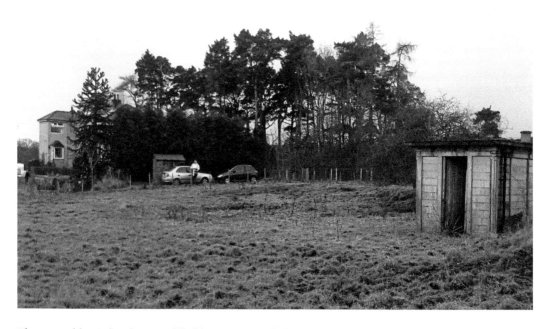

The turntable pit has been in-filled but occasional glimpses of the brickwork can be found on inspection. The concrete permanent way cabin still stands steadfast. (*Iain MacIntosh*)

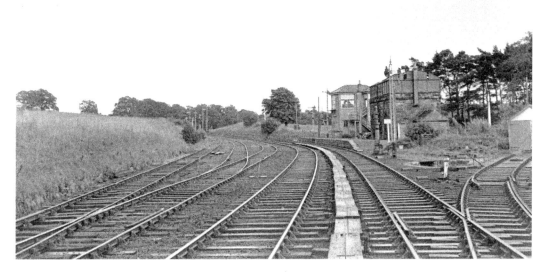

A general view south through the Wansbeck platforms with the exchange sidings and loop running through the scene. (*Roy G. Perkins*)

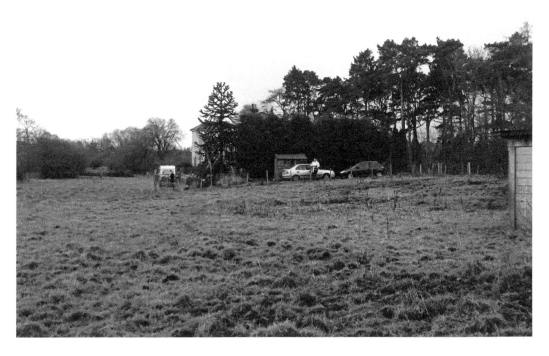

The wide open expanse, with the exception of tree growth and nature reclaiming the site, still provides evidence of the considerable siding presence once contained here. (*Iain MacIntosh*)

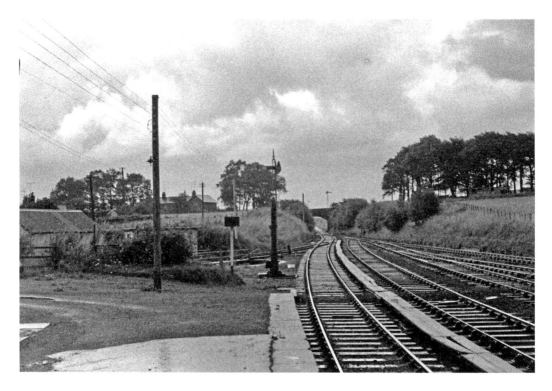

The view north towards Morpeth from the Wansbeck route platform with the siding and loop throat, turntable and road over bridge in the distance.

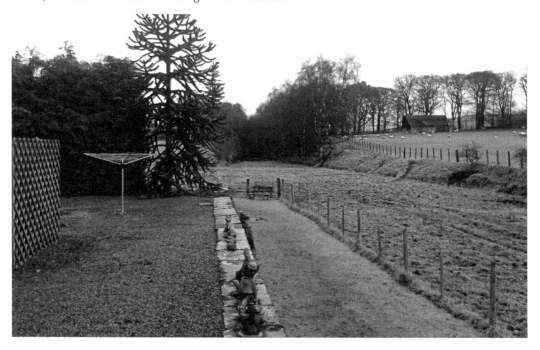

A low retaining wall still supports the heel of the cutting side up towards the over bridge despite the track's disappearance and the trees' encroachment. (*Iain MacIntosh*)

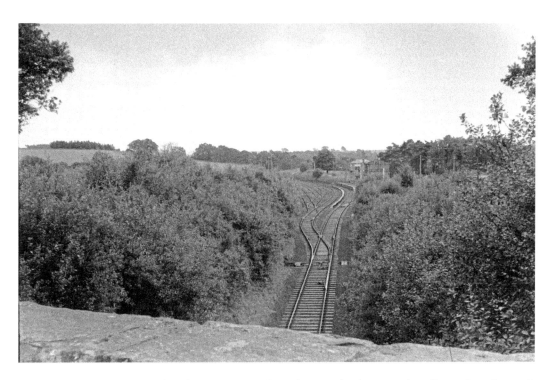

The view from the road to the station site along the Wansbeck route. The village of Reedsmouth and Station Road are just off to the right. (*Roy G. Perkins*)

Obstructed by trees, most of the buildings survive, as we have seen over the preceding pages, hidden from the glare of the main road. (*Iain MacIntosh*)

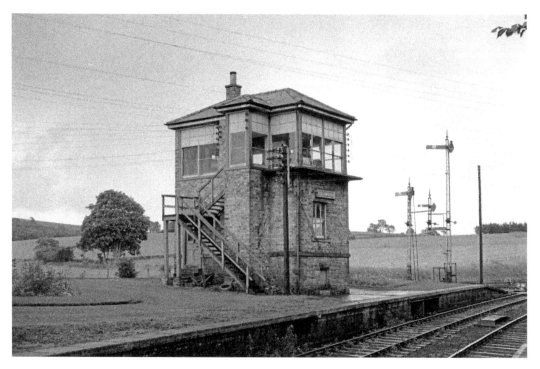

A closer view of the signal box. Only the dressed stone masonry of the original low box remains at the base, with the new build in brick on top. (*Roy G. Perkins*)

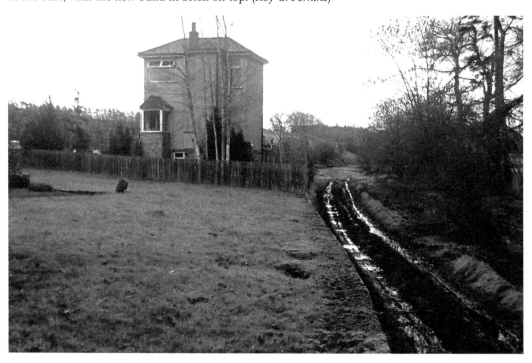

All detail of the structure now lies hidden beneath the render presumably added to hide the irregular pattern of construction, which now includes concrete block work. (*Iain MacIntosh*)

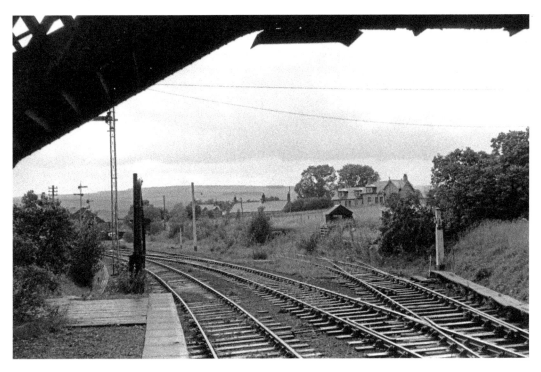

This view to the shed from beneath the footbridge reveals the proximity of the village and the pointwork into the shed approach. (*Roy G. Perkins*)

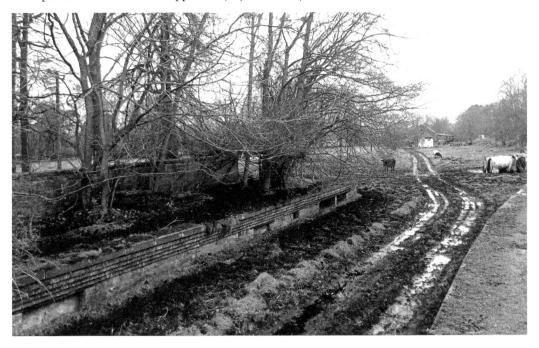

The idea of trying to take a true contemporary view was scotched for reasons already described and shown here. This view does show what remains of the footbridge foundation and the window of the abandoned underpass. (*Iain MacIntosh*)

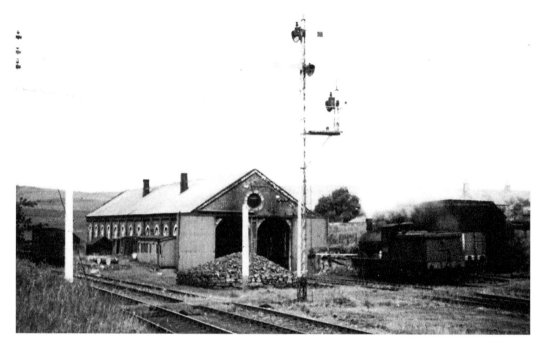

A final selection of photos around Reedsmouth begins with the shed support; what I think is a J21 is in steam outside. (*R. W. Lynn*)

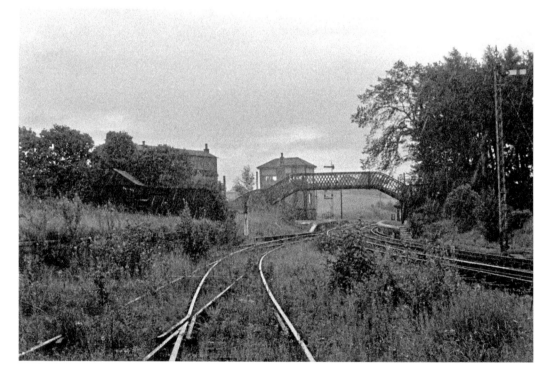

A view from the shed throat showing the shed approach sidings and the curvature of the BCR route. (*Roy G. Perkins*)

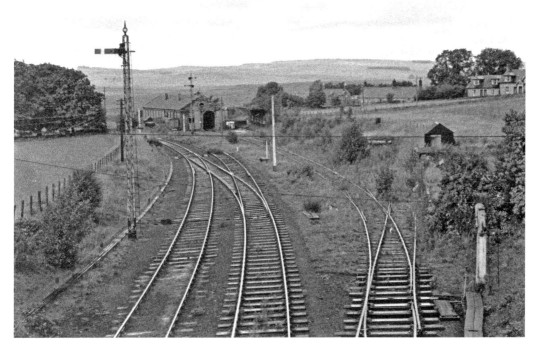

A view towards the shed with the head shunt alongside, the two road shed, coal siding and loading dock. (*Roy G. Perkins*)

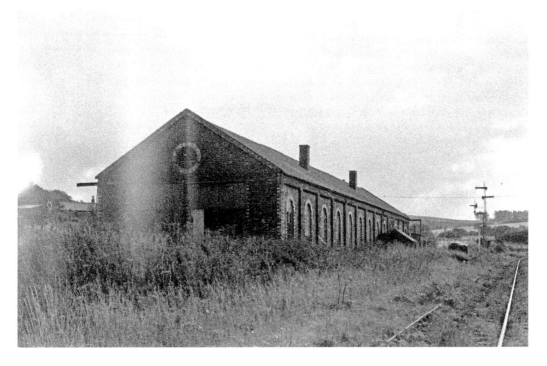

And finally a view from the rear of the shed showing the brick construction, head shunt and that both shed roads originally ran right through the shed. (*Roy G. Perkins*)

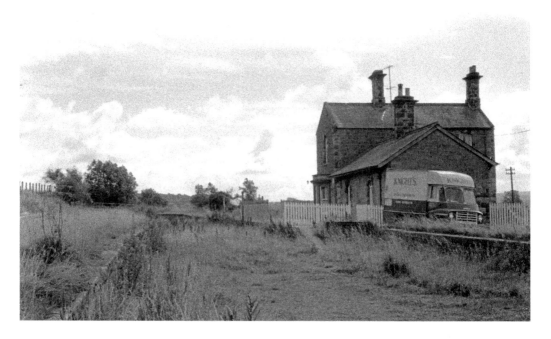

Wark station had already been closed for 4 years by the time of this 1962 study but the lady who gave me permission to take the photos had already moved in two years previously. (*Roy G. Perkins*)

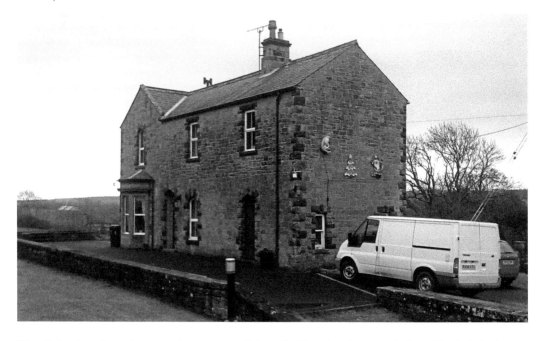

The slight alteration of perspective was a condition of taking the photographs here. The lady had her washing hanging out to dry – there was nothing that would create blushes in a publication but none the less it was a consideration I was happy to honour. The building has had a second storey added above the waiting room and the platform has been altered to remove the presence of damp. (*Iain Macintosh*)

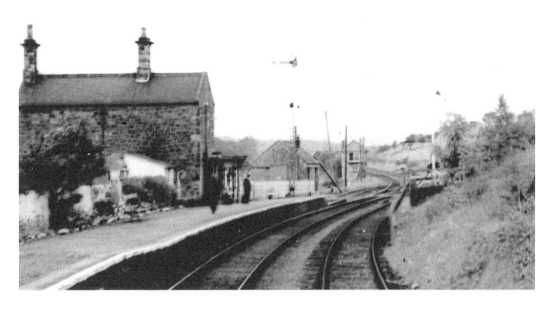

A general view with track in situ, showing the running line running through the platform, the goods shed and siding to the left beyond the platform and the loading dock road to the right.

The goods shed still survives in good order, as do all the platform and loading dock walls, a real credit to the owner and their dedication to the surviving character of the station and its immediate environs. (*Iain MacIntosh*)

The signal box was built to control the passing loop located here and stands beyond the station and level crossing for the lane to Birtley, seen running alongside the newly constructed houses which occupy the formation now. (*Roy G. Perkins*)

The houses still stand, occupying the track bed, and Birtley Lane has received little attention, still being an inch or two wider than a reasonably sized car. The signal box still stands in the woods ahead but this is not apparent from this photograph. (Iain MacIntosh)

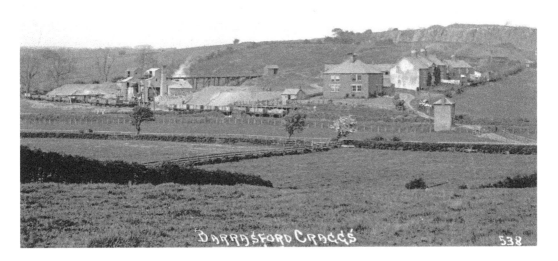

To the north of Barrasford was Barrasford quarry. It had its own internal rail system and is still active today under Tarmac although I would suspect the internal system is no more. (*R. W. Lynn*)

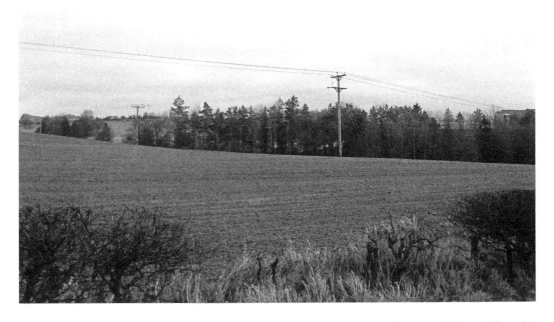

I couldn't quite ascertain the exact spot to take the contemporary photograph from, although I suspect from the top of the small hill in the field opposite. A general view therefore, from the stump of a felled tree by the roadside, is offered and the quarry working can be seen spread out from behind the trees beyond the field. (*Iain MacIntosh*)

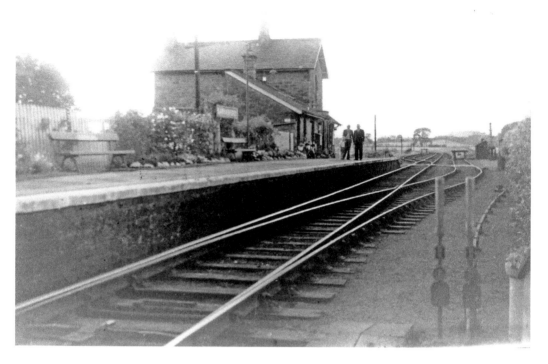

An early view of Barrasford station showing the ground frame controlling the loop line and the siding to the left beyond the level crossing. (*R. W. Lynn*)

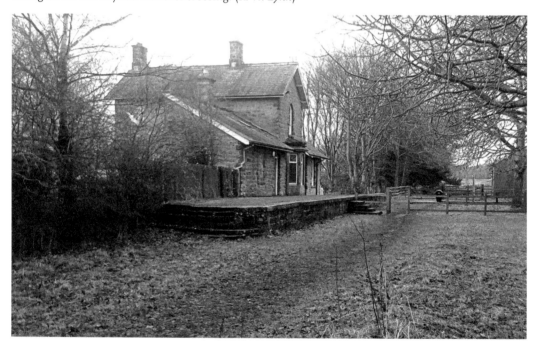

Although the platform has been shortened the station building remains in good condition and is used by the Scout Association. A short footpath follows the line south towards Chollerton. (*Iain MacIntosh*)

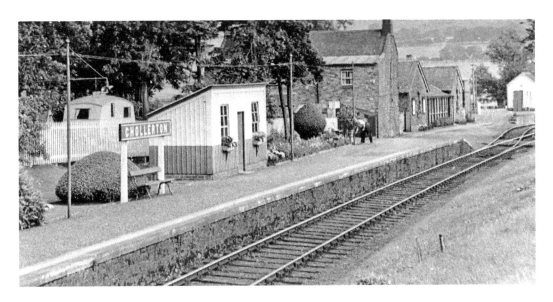

An empty but well kept Chollerton station is shown at an early date. The platform lies in a cutting with the main station buildings and two siding yard beyond. (*R. W. Lynn*)

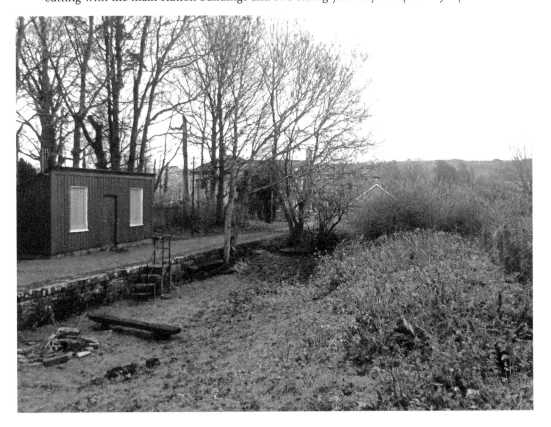

Pretty much all the station infrastructure remains although it is suffering from the damp caused by the trees today. The main station building has been extended across the goods yard site and the garden occupies the track bed. (*Iain MacIntosh*)

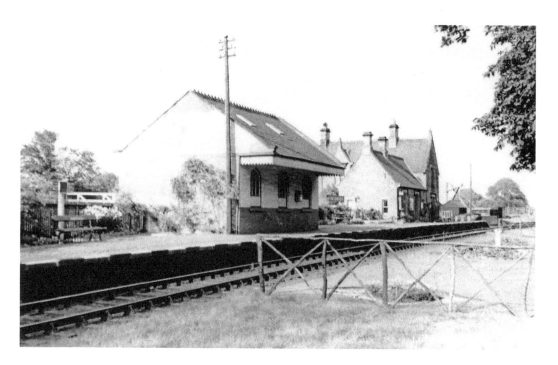

Humshaugh was a pleasant station situated on the east bank of the North Tyne, opposite Chollerford village. Originally called Chollerford, the name was altered to avoid confusion with Chollerton to the north. A substantial main building and impressive waiting room were constructed for passengers. (*R. W. Lynn*)

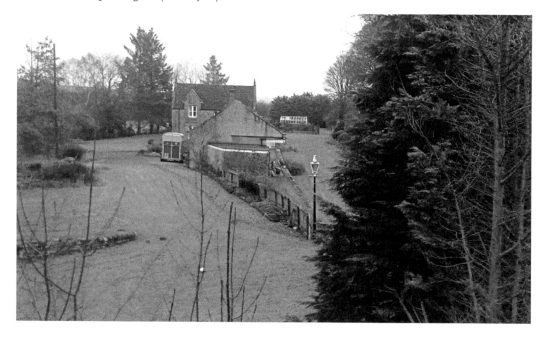

Taken from the over bridge to the south of the station, and from a different angle due to the presence of trees, the main building and waiting room remain, along with a very attractive garden area. Some alteration and extension has taken place. (*Iain MacIntosh*)

The gable end in the historic view was destroyed by fire but remained standing until the line's demise. The whole station building has been rebuilt using dressed masonry befitting the original's style. A BR Mark 1 coach enhances the image of the former station. (Iain MacIntosh)

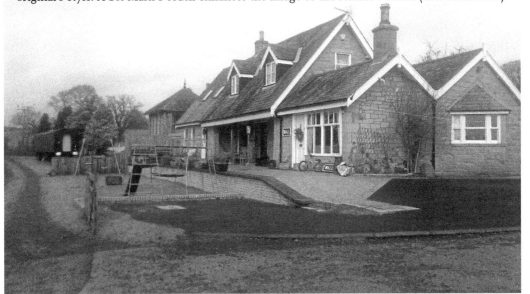

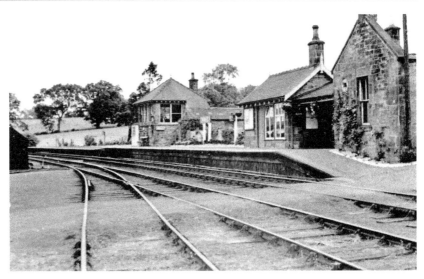

Wall station was a little way from the village of Wall and down a steeply graded road. This was the last crossing point before the double line at Border Counties Junction was reached. Restrictions on the bridge across the Tyne at Border Counties Junction meant heavy trains requiring the assistance of a pilot would come over with a single engine and be reunited with the pilot at Wall. (R. W. Lynn)

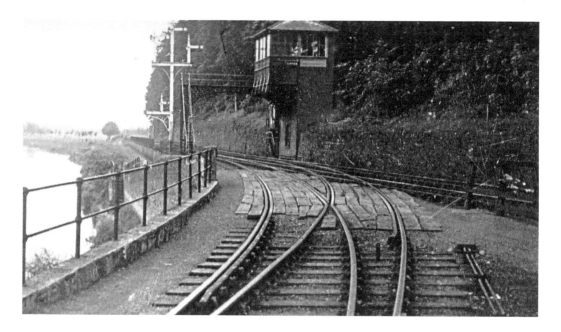

At the south side of the Tyne Viaduct lay Border Counties Junction. The double track into single leads, bridleway crossing timbers and cantilevered signal box are all clear to see. One of the signal box running-in boards resides in the WRHA collection. (*R. W. Lynn*)

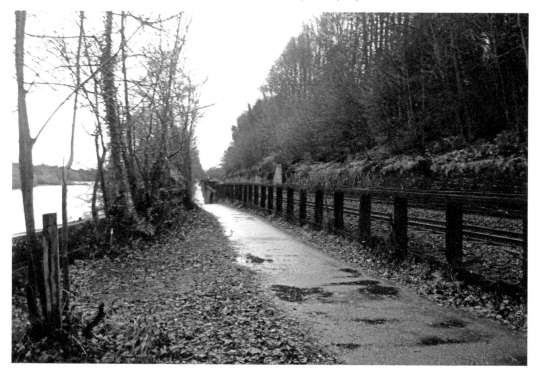

With the closure of the BCR the junction and bridge were removed, leaving only the south abutment jutting out into the Tyne and the bridleway rising up to cross the old route. (*Iain MacIntosh*)

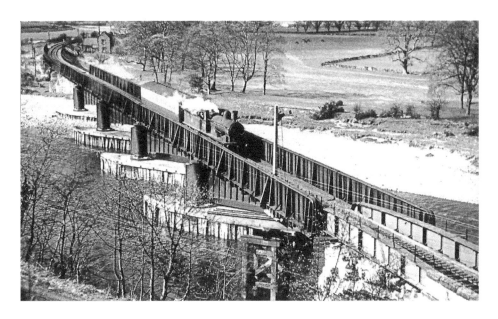

A J21 and single coach cross the Tyne in the early 1950s. The damage from the masonry arch collapse and the method of fixing it can be seen - little wonder it was weight restricted. (*G. N. Turnball/WRHA Archive*)

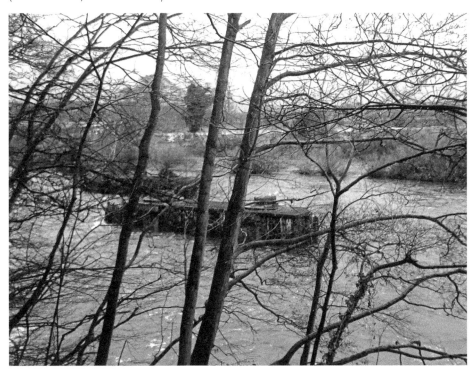

The mortal remains of the viaduct remain at the mercy of the Tyne. The flame cut pier legs protrude from the timber casings designed to protect them. (*Iain MacIntosh*)

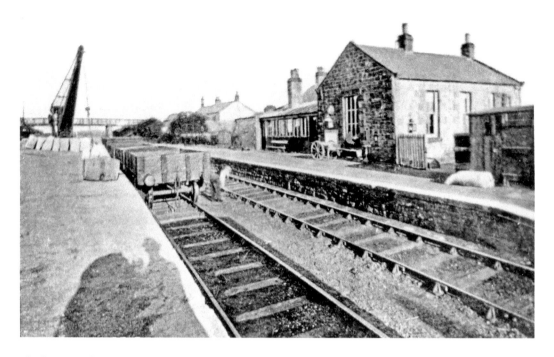

The last two photographs feature the Wansbeck route as a taster. Knowesgate station, located by the A696, served a sparse community.

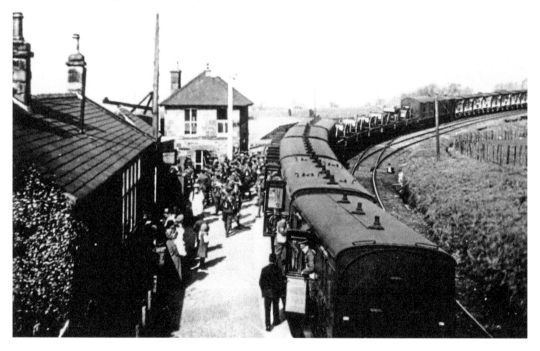

And Woodburn station catered for a widespread rural area and handled mainly agricultural traffic. During the construction of the Catscleugh Reservoir several miles to the north, a narrow gauge line was laid with an interchange being provided in the yard for transhipment of materials. (*R. W. Lynn*)